The Art of Digital Photo Painting

The Art of Digital Photo Painting

Using Popular Software to Create Masterpieces

Marilyn Sholin

LARK BOOKS

A Division of Sterling Publishing Co., Inc.
New York / London

Editor: Matt Paden
Art Director: Tom Metcalf – tommetcalfdesigns
Cover Designer: Thom Gaines

Library of Congress Cataloging-in-Publication Data

Sholin, Marilyn.
 The art of digital photo painting : using popular software to create
masterpieces / Marilyn Sholin. -- 1st ed.
 p. cm.
 Includes index.
 ISBN 978-1-60059-101-3 (PB-with flaps : alk. paper)
 1. Computer graphics. 2. Fractal Design painter. I. Title.
 T385.S4554 2008
 776--dc22

 2008021696

10 9 8 7 6 5 4 3 2 1

First Edition

Published by Lark Books, A Division of
Sterling Publishing Co., Inc.
387 Park Avenue South, New York, N.Y. 10016

Distributed in Canada by Sterling Publishing,
c/o Canadian Manda Group, 165 Dufferin Street
Toronto, Ontario, Canada M6K 3H6

Distributed in the United Kingdom by GMC Distribution Services,
Castle Place, 166 High Street, Lewes, East Sussex, England BN7 1XU

Distributed in Australia by Capricorn Link (Australia) Pty Ltd.,
P.O. Box 704, Windsor, NSW 2756 Australia

If you have questions or comments about this book, please contact:

Lark Books
67 Broadway
Asheville, NC 28801
(828) 253-0467

Manufactured in China
All rights reserved
ISBN 13: 978-1-60059-101-3

For information about custom editions, special sales, premium and corporate purchases, please contact Sterling Special Sales
Department at 800-805-5489 or specialsales@sterlingpub.com.

Acknowledgements

Books don't materialize out of thin air without the help and support of many people. Without the encouragement of Marti Saltzman of Lark Books, you would not be reading this book. She understood my vision and assigned to me the one person who turned out to be my rock of support and understanding, my editor Matt Paden. Without Matt's patience and endless attention to details, I couldn't have created this book.

Thanks to these artists and friends whom I probably drove crazy during the process of writing the book:

Chris Price artist and web designer extraordinaire, for his patience in answering my questions and supporting my work. www.studiochris.us

Karen Bonaker artist, educator and owner of the online school The Digital Art Academy. www.digitalartacademy.com

Anne Carter-Hargrove artist and educator, for rushing information to me when I needed it. www.cadmiumdreams.com

And thank you to all the members of the Digital Painting Forum who shared their knowledge and supported me through the time it took to write the book. The members of the forum are special to me and it's their friendship and creativity that gave me the idea for the book. www.digitalpaintingforum.com

Special thanks to all the gallery artists that shared their work to be published as inspiration for others.

This book is dedicated to the artist within all of us, and to Michael who encourages and loves the artist in me.

contents

Introduction

The Impressionist painters were originally ridiculed as not being artists because their never-before-seen color combinations and depictions of movement mystified the critics, yet now they are among the most revered artists in history. Digital artists have had similar problems being accepted into formal art circles, but lucky for us, that acceptance is coming more quickly than it did for the Impressionists.

Digital painting is one of the most popular and fastest growing art forms, and digital art is finding its way into galleries around the world, creating an entirely new niche of art and art prints that are being sold and collected worldwide.

In this book, I will take you step-by-step and show you how to create detailed digital artwork using popular software. The creative methods covered here will help you to stretch your creativity far beyond the lesson in front of you.

Now it is easier than ever to take your own photographs and digitally transform them into works of art that engage and mystify the viewer. The latest software programs on the market today are so sophisticated in their capabilities and so easy to use that anyone can be an artist and create their own style for their body of work. From years of experience with students at my workshops, I know that, with these lessons, you will gain the confidence to experiment and create masterpieces of your own.

To gain the most from this book, start at the beginning and do each lesson, progressing through the chapters in order. Or, you can jump around the chapters and try out different techniques, but you may find that some of the examples in the later chapters were detailed in an earlier chapter.

I have included a resources section in the back of the book, but keep in mind that websites change frequently. I will also update and maintain a resources list on my personal website (http://www.marilynsholin.com), so check there if you find a link printed here that isn't working. In addition, on my site I will include new sites as I discover them and links to more exciting tutorials and new techniques. You will also be able to download the images for each lesson we cover here, as well as short movies on the techniques.

The most important lesson I hope you learn from this book is that there are no mistakes. You can always either paint through your mistakes or start over and restore the original image source. Knowing this, you can be fearless in creating your art and continue the journey of creativity.

1
Digital Art Tools

As in any craft, having the right tools is essential for achieving great results. Digital painting is no different. With a computer that is too slow, or doesn't have enough memory, it can be agonizing to create digital art. Without a tablet and stylus to "paint" with, you have a lack of control over the brushes. Following is a list of suggested computer requirements, tools, and software you'll need to get the most from your digital painting experience. Because the main program being used is Corel Painter X, it's essential that your computer is up to speed to handle this powerful program. Not having enough memory will be frustrating by slowing down the brushes and limiting the use of larger images.

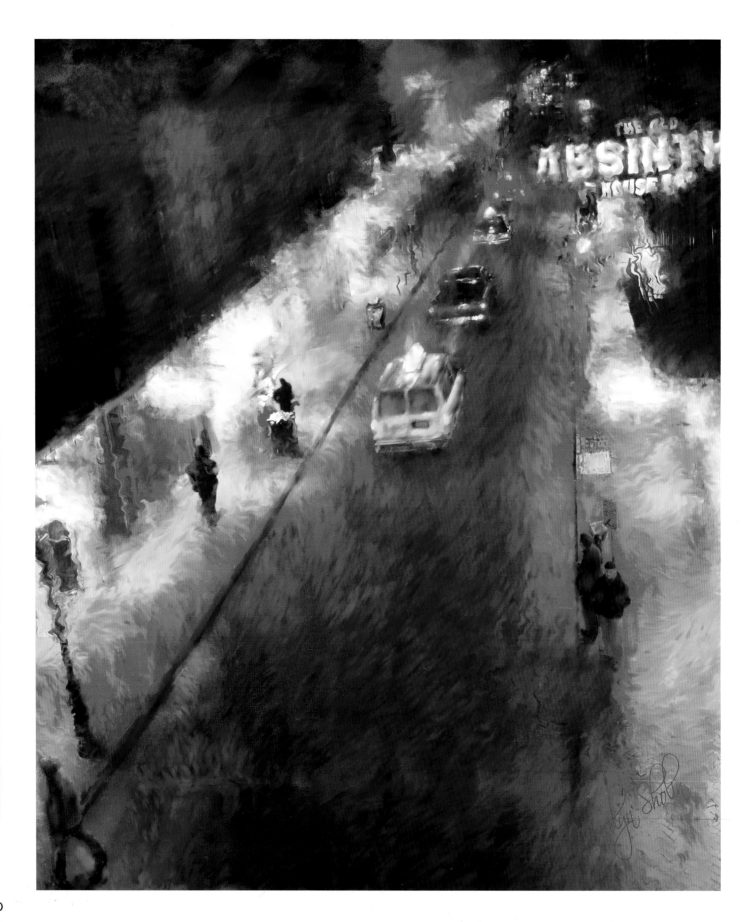

Computer

The heart of the matter is your computer. The issues to consider are memory, processor speed, and storage. The basic requirements are:

Minimum Requirements

Windows:

Windows 2000 or Windows XP (with latest service packs)

Pentium II, 500 MHz or greater

128 MB RAM
(256MB recommended)

Mouse or tablet

24-bit color display

1024 x 768 or greater
monitor resolution

CD-ROM

380MB of available hard disk space

Apple:

Mac OS X (version 10.2.8 or higher)

Power Macintosh G3,
500 MHz or greater

128MB of RAM
(256MB recommended)

Mouse or tablet

24-bit color display

1,024 x 768 or greater
monitor resolution

CD-ROM

395MB of available hard disk space

In reality, you need much more than the basics! With the heavy demand today's graphics programs place on computers, 2 gigabytes (GB) of RAM are highly recommended to have the speed you will want for painting. Review your options and buy the fastest computer you can afford—in the end, you'll be glad you did. Storage can always be off the hard drive and on multiple external hard drives. As a matter of fact, it is highly recommended that all of your art files be backed up on separate hard drives. Nothing is more frustrating than a hard drive crash and losing all your original art files.

Tablet & Stylus

Almost essential for painting is a Wacom tablet and stylus. A tablet is a digital "canvas" and the stylus is a digital pen. Together, these tools will allow you the control to get into small areas and also to work as if you were holding a real paintbrush. The best choice for the type of painting in this book is the Wacom Intuos3 in the 6 x 8 (15.2 x 20.3 cm) size. There are customizable buttons on the tablet that are programmed to be keystrokes for

your most used keys. Also, there is a zoom glider that will speed up the changing of your brush size. Best of all, the Intuos responds to pressure from the stylus instantly. While you may be tempted by price to opt for one of the other tablets, you will miss the precise control the Intuos tablet gives you.

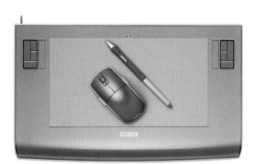

The Wacom Intous3 tablet is the best choice for digital painting.

A Wacom tablet comes with extra pen nibs for the stylus—three standard nibs, a felt nib, and a spring-action stroke nib. Try all three styles before deciding which one is best for you. Each one has a different feel and drag on the tablet. You will soon decide which one works best for your own brushstrokes.

Wacom also offers a line of Cintiq tablets that are actually monitors that can be directly painted on. These monitors allow the pen to be placed on the monitor, which reacts with realistic painting strokes applied directly to the image. The Cintiq is combined with a sensitive pen and gives one the ability to work the closest to how painting feels with traditional materials. There are many choices in the Cintiq family of monitors, and one might be right for your preferred method of painting.

On the other end of the Wacom tablet spectrum are the new Bamboo tablets. Bamboo and Bamboo Fun are entry level tablets that are enjoyable to use in any program, but have much less sensitivity to stylus pressure. The Bamboos only have 512 pressure levels while the Intuos has 1024 levels. Pressure levels are important for accuracy and for creating different painting effects just by pressing harder or softer with the stylus on the tablet.

The Wacom Bamboo is an entry-level tablet.

The first time you use a tablet and pen it will feel odd because we are all accustomed to using round, heavy mice. Give it a few days and you will never use your mouse again for digital artwork. For painting, it's a necessity because the tip can be adjusted; in Painter X, brush controls can also be modified to change the way the pen reacts. The fine lines and swooping strokes needed for painting are all much easier to achieve with a stylus pen.

The Cintiq line of tablets by Wacom allow you to digitally paint directly on the screen.

Software

Lastly, you need the software. Corel Painter X is the best natural media painting software available, and the majority of this book is dedicated to this program. Natural media refers to using digital tools that replicate traditional media such as oils and watercolors. Corel offers a 30-day, fully functional trial edition of Painter X that can be downloaded at www.corel.com. While all of the digital painting in this book is going to be started and finished in Painter X, we are also going to use some other painting software that will help create more interesting and realistic painting effects. These additional programs are plugins, stand alone programs, or both, and they will boost your creativity and allow endless options for new paintings.

Software Overview

It is always the goal of the digital painter to create paintings that do not look either too photographic or too computer generated. By occasionally switching between programs or plugins to apply different effects or filters, this goal becomes easier to accomplish.

Not every program runs as a standalone or as a plugin to Painter. On a PC computer, many will operate as either. On a Mac, they will either run as a standalone program or need to be incorporated into another graphics appli-

cation to be run as a plugin there. When installing programs, the choice will be given as to where to install the software. On a PC, choose the Painter plugin folder, which is in the Support folder, if the program can be run as a plugin. On a Mac, choose your preferred graphics program or the install package will help find the appropriate program for you. For standalone software, there is no need to choose any program or folder; it will automatically install into your programs or applications folder.

After a painting effect is created in one of these programs, it is then saved with a new name and opened in Painter X to be incorporated into the final painting. All of these programs are easy to operate and create effects that would otherwise be very difficult to achieve. They each have their own look and can all be controlled by the artist to achieve truly unique paintings.

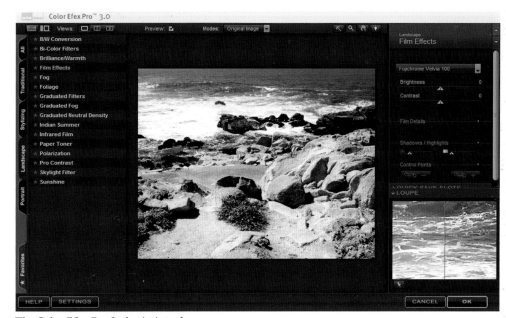

The Color Efex Pro 3 plugin interface.

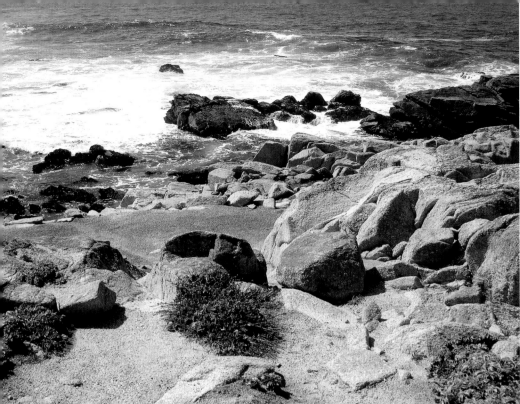

This image looks a bit dull and not detailed enough before using the Efex software.

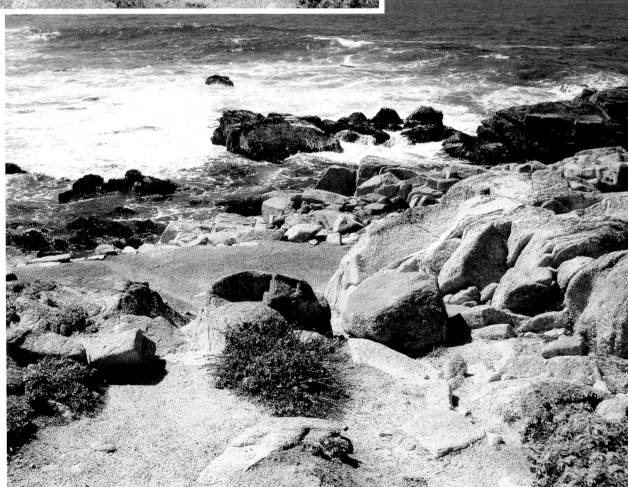

After using the Fujichrome Velvia filter in the Film Effects menu, the image looks brilliant and saturated.

Nik Color Efex Pro 3

Color Efex Pro 3 is a set of awe-inspiring filters that are both powerful and creative and cover the gamut from color changes to black-and-white conversions to funky pop art colors. The program can be used in Painter X as a plugin on a PC, or as a plugin for many graphics programs on a PC or a Mac. Nik offers a 15-Day Free Trial for all of its software at www.niksoftware.com.

Nik also has an incredible plugin called Viveza, which is an amazing image correcting software that has made color correcting easier than ever with its new U Point technology. Anyone can simply and easily make color corrections now with just a click. Though Viveza is not used in any of the tutorials in this book, it's worth downloading the trial version to see how it could be beneficial to your digital painting.

Alien Skin Snap Art

Snap Art creates beautiful, natural media artwork in a single step. Render any image in an unlimited variety of real-world art styles, including oil paint, pencil sketch, pen & ink, comics, and more. Great for stylizing photos or graphics, Snap Art works without laborious hand editing and is very versatile.

This program can be a useful addition to your toolbox; it has many different settings that will get your masterpieces looking their most painterly. Artists often use an underpainting to outline subjects within a composition. Snap Art uses edge detection to discern the objects, edges, lines, and shapes of the original image. Then, using this outline, an advanced paint engine strokes and fills this outline using the brushes and colors you specify. Loaded with hundreds of settings, Snap Art reduces a complicated process down to a simple step. For advanced users, there are detailed controls available to fine-tune a desired effect.

The Snap Art plugin offers a lot of variety for rendering images in exciting ways. Here, the Pencil Sketch setting is used.

Currently, the Snap Art demo software is available for a 30-day trial. Visit www.alienskin.com/snapart to register for the demo version.

Snap Art offers many settings for lots of creative effects.

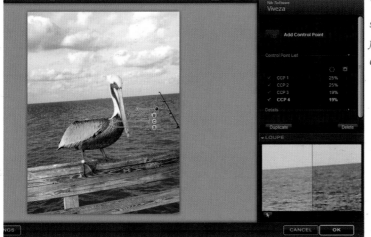

Vivenza is a great software option for making easy color corrections.

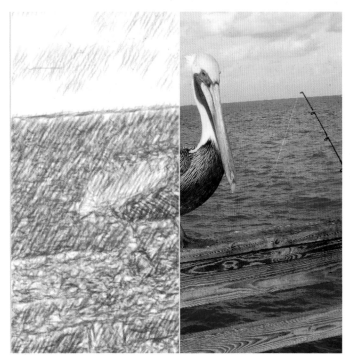

The split screen preview in Snap Art allows you to see the effect before you choose to apply it.

Host requirements

Snap Art is a plugin and must be used with one of the following host programs:

Windows Hosts:

Adobe Photoshop CS or later

Adobe Photoshop Elements 4 or later

Adobe Fireworks CS3

Corel Paint Shop Pro XI or later

Corel Painter X

Mac Hosts:

Adobe Photoshop CS2 9.0.2 or later

Adobe Photoshop Elements 4.0.1 or later

Adobe Fireworks CS3

TwistingPixels ArtStudioPro

Twisting Pixel's ArtStudioPro software offers many creative filters that will turn ordinary pictures into works of art. There are three versions of the software, ArtStudioPro Volume 1, ArtStudioPro Volume 2, and ArtStudioPro Classico, each offering different effects worth owning.

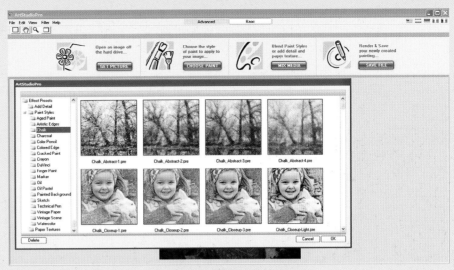

The ArtStudioPro interface set in Basic mode.

On Windows and Macs, the program installs as a stand-alone application or as a plugin to Photoshop Elements, Photoshop (7, CS1, CS2, & CS3), Paint Shop Pro, and Painter X. By purchasing a single copy of TwistingPixels products, you get one license to use for both your PC and Mac (if you use both, this is a nice feature), as long as only one version is running at a time. Trial software can be downloaded at the TwisitngPixels website at www.twistingpixels.com. A watermark will appear on the images created in this program until the full version is purchased.

Most of the programs mentioned here have demos that can be downloaded, installed, and tested. It's always a good idea to try demos first to see if the software is a good fit for your working style. After the demo expires, you can decide whether to purchase the program or not. Try using the demos for the exercises in this book.

With this toolbox of painting programs and the power of Painter X, it's easier than ever to fully realize actual paintings from photo references. All the extra programs are simple to use, yet allow advanced users to go further by tweaking their settings and creating and saving new ones. Favorite settings can be saved in most of the programs to be used over and over. As we go forward in the book, it will become obvious that combining multiple programs is the best method to create personalized digital art that does not look like it was created in a computer.

2

Painter X: Getting Started

Learning your way around Painter X is relatively simple once the basics are out of the way. If you are familiar with other image editing software, you will find that Corel has made it easy for you to get around by using many of the same tools and even the same basic layout as other popular programs. We'll start with a review of the workspace, Toolbox, and palettes, and end with a tutorial on prepping an image for painting.

Welcome to Corel Painter X!

Access files, tutorials, settings, and artwork from renowned Painter Masters.

Create new document...

Open an existing document...

Select recent document...

Recent Documents

Open a template...

Document Templates

What's new in Painter X....

Marilyn Sholin www.marilynsholinfineart.com

Working in Painter X

The Welcome Screen

When Painter is first opened, a welcome screen appears. There are some hidden gems on this screen, which looks like an opened book with colored tabs on the right hand page. If you are connected to the Internet, click the second tab on the right and the book will open to show a variety of Corel Painter Masters' artwork, as well as list their respective websites where one can see more of their work. Continue to press this tab and it will keep changing to show new paintings and artists.

There are also Painter Quick Tips in the book that can be accessed if you are connected to the Internet. Click the last tab, which looks like a globe, and the left page will show a list of quick tips to use in Painter.

If you prefer to not have the book open when starting Painter, click the next to last tab that looks like tools; at the very bottom there is a box that says, "Show this dialog at startup." Uncheck that box and the book will not open when Painter is started. Accessing the welcome book again is easy by going to the top of the Painter screen and clicking HELP>WELCOME.

To move past the book and into the Painter workspace, click the top right X and it will disappear.

The Painter X Workspace

If you're familiar with just about any other type of software, you'll intuitively know the workspace as the area within the program where you interact with the software. In Painter X, the workspace is the area that shows your open images or paintings, and your tools and other palettes. Some items, like the Tool-box, should appear in the workspace by default when the program is opened. Sometimes, however, you'll have to open these palettes yourself or perhaps modify the workspace to your working habits. If you go to WINDOW in the Menu Bar, you'll find you can open and close the palettes here (see page 25).

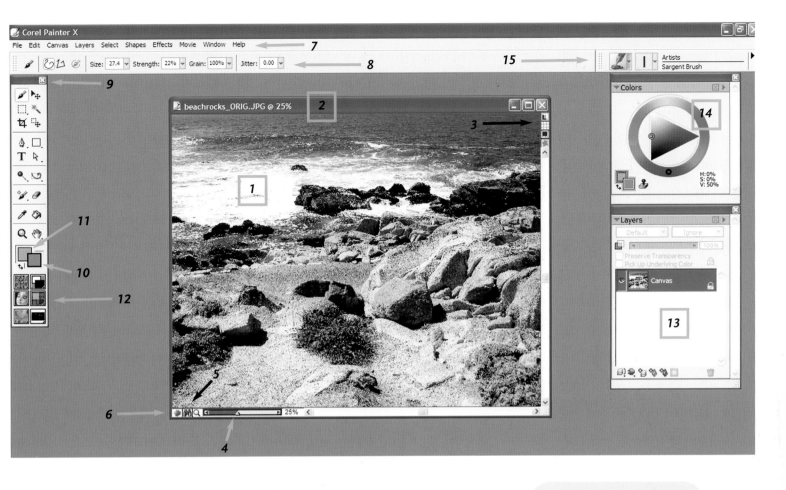

NOTE: Sometimes you may find that palettes are not shown when you open Painter X, or that you want to revert to the default palette arrangement. To display the default settings, go to WINDOW>ARRANGE PALETTES> DEFAULT.

Window	Help	
Workspace		▶
Hide Palettes	Tab	
Arrange Palettes		▶
Zoom In	Ctrl++	
Zoom Out	Ctrl+-	
Zoom To Fit	Ctrl+0	
Hide Toolbox		
Hide Property Bar		
Hide Brush Selector Bar		
Brush Controls		▶
Color Palettes		▶
Library Palettes		▶
Hide Layers	Ctrl+4	
Show Channels	Ctrl+5	
Show Text	Ctrl+6	
Show Scripts		
Show Info	Ctrl+7	
Show Tracker		
Show Image Portfolio		
Show Selection Portfolio		
Show Underpainting		
Show Auto-Painting		
Show Restoration		
Show Divine Proportion		
Show Layout Grid		
Show Brush Creator	Ctrl+B	
Custom Palette		▶
Screen Mode Toggle	Ctrl+M	

Under Window is where you will find all the palettes for Painter X.

1. Canvas

2. Document title bar

3. Toggle Tracing Paper

4. Scale slider

5. Navigation icon

6. Drawing Mode icon

7. Menu Bar

8. Property bar

9. Toolbox

10. Main Color

11. Additional Color

12. Selectors

13. Layers palette

14. Colors palette

15. Brush Selector bar

This is the Painter Toolbox. By hovering over a tool with the cursor, its name will appear.

The Toolbox

Go to the Toolbox and hover over each tool with your cursor. You will see that the name of each tool will appear in a moment telling you what it is. The Toolbox is where you'll find just about everything you need to accomplish a painting. We'll review each tool individually, defining its capabilities. Note that some tools are hidden, or stacked, below another tool in a "flyout" menu. To view these hidden tools, click and hold the cursor on the tools that have a small arrow in the bottom right corner.

The descriptions of the Tools are listed by their order of appearance in the Toolbox, starting in the top left corner.

Brush: *The brush is used to paint or draw lines. The brushes are arranged in categories on the upper right side of the workspace in the Brush Selector bar. Brushes are categorized by media type in the left box, called Brush Category, while all the brush styles available within that media are in the right box, named Brush Variant. Click on either box to view and select among the options. In the Brush Variant box, the numbers next to the brush names represent the size of the brush. Notice that one brush might have three different sizes to choose from.*

This is the Brush Category drop down menu.

This is the Brush Variant drop down menu.

Layer Adjuster tool: *This tool is used to select and move layers.*

Rectangular Selection tool: *Used to make rectangular selections.*

Oval Selection tool: *Used to make oval selections.*

Lasso: *Allows you to draw unique selection shapes.*

 Magic Wand: *This tool is used to select areas of similar color in an image.*

 Crop tool: *This tool is used to crop out, or remove, edges of an image.*

 Selection Adjuster tool: *Used for choosing and moving selections created with the Lasso tool.*

 Pen: *Use the Pen tool to make line and shape paths by creating adjustable anchor points with a click of the stylus.*

 Quick Curve tool: *Similar to the Pen, this tool creates line and shape paths with adjustable points. Lines are created by dragging the stylus rather than clicking it.*

 Paint Bucket: *This tool fills areas with color. Use the property bar to select various settings such as color and location of fill.*

 Rectangular Shape tool: *Creates rectangular shapes.*

 Oval Shape tool: *Creates oval shapes.*

 Text tool: *Use this tool to add type to your image. Type is adjustable using the Text palette.*

 Shape Selection tool: *Use this tool to adjust the anchor points created with the Pen or Quick Curve tools.*

 Scissors: *Use the scissors to cut line paths apart.*

 Add Point tool: *Creates additional anchor points on a path.*

 Remove Point tool: *Delete anchor points from a path.*

 Convert Point tool: *Switches anchor point types between 'smooth' and 'corner' options.*

 Dodge: *Used to lighten any part of an image, the Dodge tool is adjustable with size and opacity sliders.*

 Burn: *The opposite of the Dodge tool, the Burn tool lets you darken areas of an image.*

 Divine Proportion tool: *This tool superimposes a grid over the image based on a composition method found repeatedly in nature and art.*

 Perspective Grid tool: *Provides adjustable grid lines for many parts of the image.*

Layout Grid tool: *Use the Layout Grid to superimpose lines over the image that can help you plan your composition based on preset guides.*

Cloner: *This tool is a fast way to call up the Cloner brush variant last used.*

When this is clicked while painting, the last brush set as a Cloner will automatically be the active brush to paint with.

Clone Rubber Stamp: *allows you to clone brush strokes already painted. Press Alt (PC) or Option (Mac) and click to define the source area for cloning. This is an easy way to replicate brush strokes you like in the painting.*

Eraser: *Delete areas from an image by using this tool; it's size and opacity are adjustable with sliders in the property bar.*

Dropper: *Selecting a color from the image using the Dropper establishes it as the current color in the Color palette.*

Magnifier: *Zoom in or out on an image with this tool.*

Grabber: *Use the grabber to scroll around in an image without using the scroll bars on the bottom and side of the canvas.*

Painter X Shortcuts

Quick Key commands are a fast way to access tools, palettes, and functions without having to navigate to them with the mouse. Following are some of the more common commands that can be very useful to know. As you get more used to keyboard shortcuts, you'll wonder how you ever lived without them!

Pressing the following letters will quickly toggle between tools in the Toolbox.

M	Magnifier
G	Grabber
B	Brush
D	Dropper
K	Paint Bucket
L	Lasso
Spacebar	Scroll Image with Grabber

Other often-used shortcut commands:

Save As: Shift + Command + S (Mac); Shift + Ctrl + S (PC)
Undo: Command + Z (Mac); Ctrl + Z (PC)
There is a maximum of 32 undo steps as a default setting.

Select All: Command + A (Mac); Ctrl + A (PC)
Cut: Command + X (Mac); Ctrl + X (PC)
Copy: Command + C (Mac); Ctrl + C (PC)
Paste In Place: Command + Shift + V (Mac); Ctrl + Shift + V (PC)

Adjust Colors: Shift + Command + A (Mac); Shift + Ctrl + A (PC)
Brightness/Contrast: Shift + Command + B (Mac); Shift + Ctrl + B (PC)
Equalize: Command + E (Mac) Ctrl + E (PC)

Painter X Palettes

Painter has special palettes that allow you to navigate and select among various important parts of the software, such as Layers, Color, Text, and more.

These palettes are all accessed from the WINDOW menu. In this menu, if it says SHOW next to a palette, it means the palette is closed and can be opened. If it says HIDE, it means the palette is already open and on your workspace. Sometimes palettes can be hidden by other palettes or paintings in a cluttered workspace; remember that you can always revert to the default palettes in the WINDOW drop down menu to clean things up. In this section, we'll review the most commonly used palettes and a few advanced ones. If these palettes seem a little confusing now don't worry; they'll make more sense after a few of the lessons in the book. You can always come back to the palette descriptions as a reference tool later.

Layers

The Layers palette will be used frequently and has a number of controls and options. Until an image is opened in Painter, the choices at the bottom of the palette are faded. When the image is opened, then the choices are selectable.

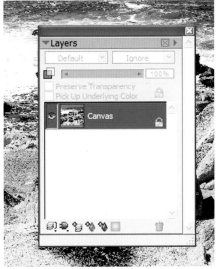
The Layers palette.

The layers are listed in the palette from the top layer down to the bottom. The main canvas layer is always at the bottom and new layers are stacked on top of it. A layer is activated by clicking on it, at which point it immediately becomes the layer that is being painted on. Empty layers can be added to paint on, and then using the BLEND COMPOSITE METHODS (found in the upper left drop down menu of the Layers palette), different effects can be achieved by specifying how the layer will interact with those underneath it. The Opacity can also be lowered to change the strength of the layer.

A layer can be deleted by highlighting it and clicking the trashcan in the lower right of the Layers palette. A layer can be hidden by turning the Eye icon off on the left side of the layer. This makes it easy to see and define your work on each layer. Use the LAYERS menu in the Menu Bar to drop, merge, delete, move, and group layers.

Layer names can be changed by double clicking the layer itself; a dialog box will come up that allows the name change to be filled in.

Color

Open the Color palettes by selecting WINDOW>COLOR PALETTES>SHOW COLORS. You'll see that there are three palette options shown here: Color, Mixer, and Color Sets.

Color palette: Displays a round color wheel and is primarily used to select foreground and background color.

The Color palette.

Mixer: The Mixer palette mimics the traditional experience of mixing colors on an artist's palette. Apply two or more colors to the Mixer pad, blending them together to get the color you want. Colors can be saved, loaded, and reset on the Mixer palette, saved as mixer swatches, and saved to color sets.

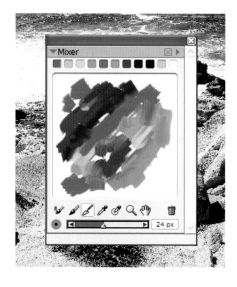

Color Sets: Painter provides several color sets — Corel Painter Colors, Mac OS, Windows system palettes, and the Pantone Matching System are a few. The default color set is Artists' Oils Colors, which is based on the color values of real-world oil paints. It is important to know that Artist' Oils is the default so after using other color sets, the default one can be reinstalled.

Only one color set can be open at a time. New color sets can be saved from images or other paintings and also from the Mixer pad.

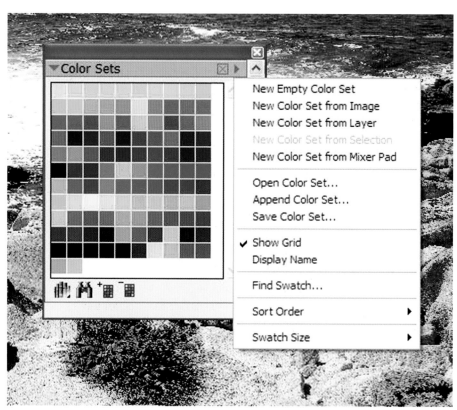

The Color Sets palette with the drop down menu showing all options.

Brush Tracker Palette

Another great feature of Painter X is the Brush Tracker. To open, go to WINDOW>SHOW TRACKER. This little palette will keep track of all your brushes as they are used. Be sure to set it to LIST and not to STROKE. This will list the name of the brush rather than show the image of the stroke, which can be confusing. To set it for LIST, click the arrow to the far right of the word TRACKER and a menu will drop down. Choose LIST from that menu.

The last brush used is always at the top of the list and whenever the brush attributes are changed, the brush is listed again with the new attributes.

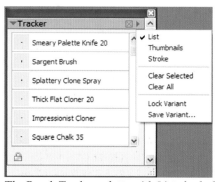

The Brush Tracker palette with List checked.

*Go to Window>Brush Controls
For the Brush Controls drop down menu.*

Brush Controls

Each brush has specific properties that can be modified. In BRUSH CONTROLS, each of those properties is listed with the options to alter the brush and explore how it will change. For instance, using the CAPTURED BRISTLE BRUSH in the ACRYLICS category, we can change the brush in the Spacing option. Change SPACING to 45% and the bristles spread. Changing the COLOR VARIABILITY from HSV to COLOR SET creates a rainbow brush that looks totally different. Although Painter is already loaded with hundreds of brushes, each brush can create more variations so the choices are endless.

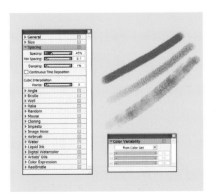

Using the Brush Controls palette, three different brush styles are created from the same brush. The first stroke is the default setting for the brush. The second has the Spacing modified, while the third has the Color Variability changed.

Brush Creator Palette

The Brush Creator palette is a playground for brushes. It will create new variations of brushes for you automatically, or the specific brush attributes can be changed until you find a brush that meets your expectations. This is another palette that is similar to Brush Controls in that it changes the brush settings. But this palette includes more options than the Brush Controls.

There are three elements to the Brush Creator: the Randomizer, the Transposer, and the Stroke Designer. The Randomizer creates random brush settings for the selected brush category and variant. The Randomizer is without a doubt the easiest and most fun to try using any brush. It will immediately create new brush variants that can be saved with new names to be used again later.

The Transposer creates new brush settings based on the transition from one brush category and variant to another.

The Stroke Designer lets you control the size and shape of the media applied by a brush, the way the dabs are repeated in a stroke, the media (usually color) that flows from a brush, and how a brush interacts with underlying pixels.

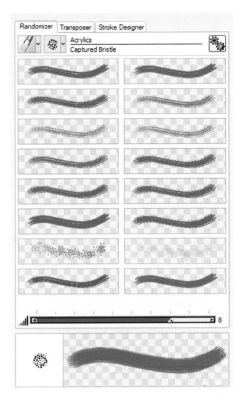

The Randomizer selections.

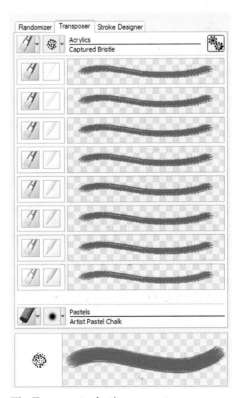

The Transposer selections.

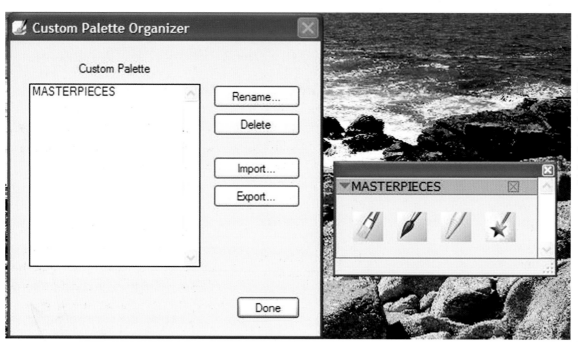

The Custom Palette Organizer is seen to the left; this is where all of the custom palettes appear by name. On the right is how the Custom Palette appears on the screen in Painter when loaded with your brush choices.

Custom Palettes Organizer

Custom palettes are a way of creating a shortcut that is on the workspace to hold brushes and/or actions. An action would be something that is used often in Painter; if it is on the Custom Palette, it saves time to click it rather than finding it through the drop down menu choices. An example of this would be to put EQUALIZE or SAVE AS as an action on the Custom Palette.

The Organizer permits many different custom palettes to be created and also exported to other folders. These exported custom palettes can be shared with others using Painter X.

Preferences

There are a few preferences in Painter that should be set before painting begins.

On a PC, go to: EDIT>PREFERENCES

On a Mac, go to: Corel Painter X menu>PREFERENCES

General:

Uncheck: Enhanced Brush Ghost

Uncheck: Switch to Cloner brushes under Quick Clone

Change: Brush Size Increment from "1" to "5"

Brush Tracking: Run your stylus over the tablet a few times to register your type of brushstroke whether it's light or heavy. Brush Tracking customizes how Corel Painter responds to your stroke pressure and speed. If you are finding that it's necessary to press very hard on the tablet to record your stroke, then use BRUSH TRACKING to correct it automatically.

Undo: Default setting for UNDO is 32. Be sure it is set for that.

Save: Check Create Backup on SAVE box. This will save your paintings as you work in case you forget to save them. Those files with .bak on the extension are the backup files. After your painting is done they can all be deleted.

In COLOR SPACE, choose RGB for both TIFF and PSD files.

Preparing Files for Painting

Now that you have a basic understanding of the Painter X workspace, tools, menus, and palettes, we can start thinking about getting into the fun stuff—painting! The first step in any digital painting is to prepare the image you have chosen to work on. Pictures taken with a digital camera are rarely exactly what is needed to begin digital painting. Image resolution and size are important to specify before you begin, and it helps to create and maintain a consistent naming and filing system.

Image Resolution

It's important to understand your image resolution and paint in the correct one. Many digital artists accidentally start their paintings at too low a resolution that renders them viewable on a computer screen, but unfit for printing. Most digital cameras do not automatically size the files correctly for printing.

For instance, my favorite point and shoot camera creates files that are 42 x 32 inches at 72 dpi (dots per inch) when they are loaded onto the computer. Before I paint or print, it is essential that I change the size of the image and the dpi. I use an image editing program to change the images to 12 x 9 at 250

dpi your camera might not take pictures this big, however, now I have a printable image size and resolution that I can begin painting on; any painting applied to this image will also be the correct resolution for printing output. The actual pixel size of these two files is the same, but for purposes of painting, it's better to work on the smaller image. A good range to work in is 150–300 dpi.

NOTE: In the lessons in this book, you'll see that brush size settings are often suggested for a given brush used on a particular image. This does not mean that this brush size should be considered the best for all similar paintings you might create. Because the size or resolution of your personal pictures will most likely be different than the ones supplied for the tutorials, you'll need to experiment and find out what settings work best in your paintings. In the tutorials, any settings that are not stated are left at their defaults.

Resizing your Files

Resizing your files can be done in your favorite image editing software or in Painter X.

Resizing in Painter X:
Choose FILE>OPEN; choose an image from your computer.

Go to FILE>CANVAS>RESIZE. The Resize dialog box opens
Be sure the box to Constrain File Size is clicked. This will ensure that the image proportions stay the same.

Use the drop down menus to change the size to inches.
Enter your width or height measurements and check to see that the dpi changed to an acceptable number when the measurments were changed.

Naming and Filing

Once you have your file ready to paint, I recommend that it's renamed to suit the image so it's easier to recognize, and also use the word ORIG at the end of it. The latter denotes that it's the original file that has not been painted on yet. For example: **dsc003781.jpg** would become **ferriswheel_ORIG.jpg**. It's much easier to find your files if they are named and not just numbered. Your computer is probably bogged down with hundreds of files starting with your camera's file name designation. Also, keeping a separate original file allows you to start over fresh if you don't like the work you've done. Create a new folder for each painting when you start and save the ORIG file there. Name the folder the name of the file, in this case: ferriswheel. Now it's easy to save all the different renditions of the painting to one folder and keep them together.

Saving Your Files for Easy Handling

It is very important to practice good methods of saving your files so they are organized and easy to find. It is highly recommended that your files are saved in a numerical order so it's easy to see what version is being worked on.

Use a method similar to the one described here to name your files: Imagine you have an image of a Ferris wheel in your camera. Once downloaded to your computer, the original file from the camera should be renamed ferriswheel.jpg and should be saved in the ferriswheel folder as we discussed. After it's color corrected and ready to be painted, it should be named **ferriswheel_ORIG.jpg** so you can always return to the corrected version of the file. Begin painting on the **ferriswheel_ORIG.jpg** file. Subsequent files should be named by adding a number and possibly adding more information that represents the changes made. For example, the next file could be named ferriswheel_01.jpg after starting the painting process. A later version of the painting could be labeled **ferriswheel_02_sketch.jpg** if a sketch filter was applied, and so on. When this is done correctly, the different versions will all line up neatly and in order in your folder.

It's important to have an organizational method because there will be so many versions of each painting. Also, by saving versions as you go, you have a history of the painting you can return to if you decide to make changes.

The process of saving is FILE>SAVE AS; choose the folder that has been designated for the project and then name the file. Do not choose FILE>SAVE as that will overwrite your last saved image and you will lose it.

Retouching

The best files to paint are those that have been corrected and are "clean" images. If the photo is of a person, it is best to do whatever basic changes and retouching would be done in your favorite image editing software first. Correct major imperfections, but also remember that there will be smoothing of the imperfections as they are painted through. Color saturation can also be enhanced in preparation for painting if obvious corrections can be made. Once the corrected image has been saved with ORIG as the tag word at the end of the file name, the photo is ready to be painted into a masterpiece.

Downloading Images

Before we jump into the next chapter, you should go ahead and download all of the pictures we use in this book as sources to create paintings.

To download the images, go to: www.larkbooks.com/digital/photopaint

Here you'll see all of the pictures you'll need to follow the lessons in this book. Click on each thumbnail and it will download to your desktop. For the sake of order, I suggest creating a folder on your desktop named something like Photopaint_originals, and placing all of the files inside. While you won't need some of the images until the end of the book, it's easier to download them all now so they're easily available when you start a new chapter.

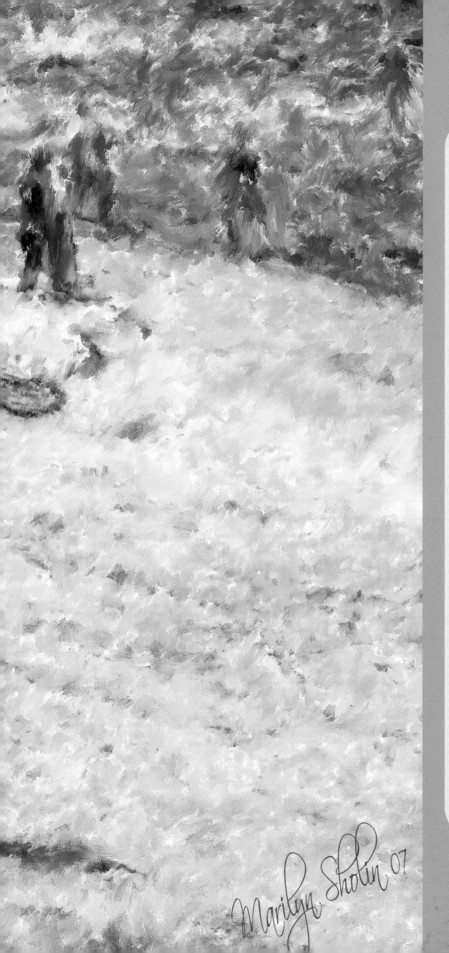

Marilyn Sholin 07

3

Introducton to Working in Painter X

Painter X is an incredibly exciting program. In the past, you may have dreamed of becoming a talented painter in a number of styles. However, it's hard to attain a mastery of strokes and color in one style, let alone three or four! With Painter's preset brush styles, you can use your everyday pictures as references and paint in just about any fashion you can dream of. After learning some of th key aspects of the program in this chapter you'll be ready to make beautiful digital art that looks like a real painting.

About Painter X

Painter X is the most sophisticated software for digital painting that has ever been developed. This latest version has many options and creative abilities never available before now. There are automatic backups of your paintings, color matching abilities, and natural media brushes that not only emulate real brushes, but are totally customizable so you can tweak them to your preferences.

In this chapter, we're going to look at two important and exciting features of Painter, Auto-Painting and Clone painting. Knowing how to control these two aspects of the program will open up lots of creative possibilities that we'll continue to use in projects in later chapters. In the process of covering these two features, we'll also get more comfortable with the Painter workspace.

Auto-Painting

Auto-Painting is a fun and fantastic part of Painter X. After selecting a Brush Category and a Brush Variant, Painter X will paint an image before your eyes in a style based on your brush choices. How far you choose to let the painting proceed, and how detailed the painting becomes, is up to you since you can stop the Auto-Painting at any point. Auto-Painting is a very fast way to get painterly effects with little effort, so it's a good way to start many new works.

The first step is to open a picture file in Painter that you want to create a painting from. If you haven't done so already, follow the directions on page 30 to download the images used in this book's lessons.

NOTE: All brush sizes suggested are relative to the tutorial images (see Image Resolution on page 29 for more information). For your own images, these settings are suggestions to start with. For any settings not supplied, it can be assumed that they are left at their defaults.

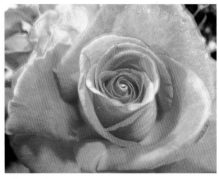

This is the image we'll use to learn how to Auto-Paint.

Choose FILE>OPEN, select **rose_ORIG.jpg**.

Go to WINDOW>SHOW UNDER-PAINTING.

This brings up three palettes that are grouped together: Underpainting, Auto-Painting, and Restoration.

Starting at the top of the palette in Underpainting, select the drop down menu COLOR SCHEME.

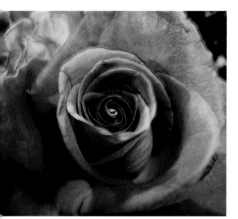

These are the color scheme choices.

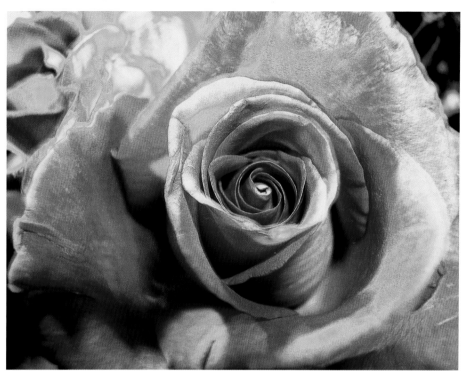

The rose after the Classical Color Scheme and Intense Color have been applied.

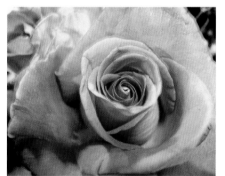

Color scheme: Classical

Color scheme: Chalk

Select the different options to see how they affect the same rose.

The colors in CLASSICAL are really interesting, so select this option. Going to the next drop down menu, PHOTO ENHANCE, choose INTENSE COLOR.

Use the sliders to adjust the colors, if desired. (They weren't changed in this example.)

Adding a little Edge Effect from the drop down menu in the Underpainting palette would be interesting.

Go to EDGE EFFECT, select JAGGED VIGNETTE from the drop down menu, and press the APPLY button.

Click the QUICK CLONE button in the bottom right of the Auto-Painting palette.

Turn off the image so only the painting shows by going to the TOGGLE TRACING PAPER icon in the top right corner of the canvas, just above the scroll bar. Once clicked, the image will seem to disappear and be totally white, but this is your canvas showing and the image is under it.

The Toggle Tracing Paper icon.

Choose the Brush: ARTISTS / SARGENT: SIZE: 30

The size of the brush can be changed using the Size slider in the Property Bar at the top left of the screen. The other default settings for the brush are correct.
Press the Rubber Stamp in the Color Wheel to use the brush as a Cloner (we'll learn more about this in the next section).

Note that the Color Wheel is now faded when the Rubber Stamp is clicked. This means your brush won't be laying down paint; instead, it will be acting as a Cloner brush.

This is how the image will look as it is painting.

Once the Rubber Stamp is pressed, the color wheel appears faded to show the brush is now acting as a Cloner.

Click the PLAY button (a green arrow at the bottom right of the Auto-Painting palette) to begin the Auto-Painting.

Let the brush Auto-Paint for a while, then stop it using the STOP button (a red square next to the PLAY button). Make the brush smaller, Auto-Paint for awhile, press STOP, then repeat with a smaller brush. The smaller the brush, the more detail added to the area being painted. Leave the scratchy-looking white areas as they look like the canvas showing through the paint.

Now the image needs sharpening to truly "pop" all the brushstrokes.

Go to EFFECTS>FOCUS>SHARPEN.

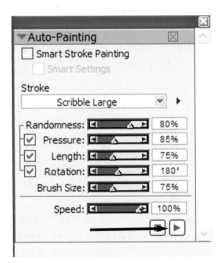

Press the Play button to begin Auto-Painting.

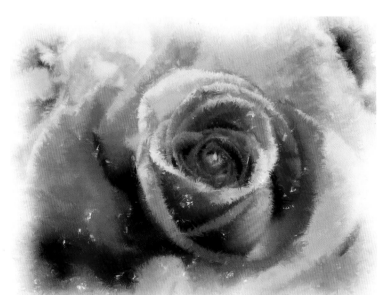

The rose image has been Auto-Painted using different brush sizes.

The Art of Digital Photo Painting: Using Popular Software to Create Masterpieces

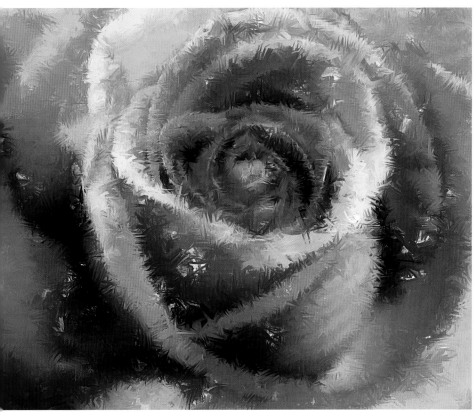

Here's a close-up view of the brushwork after Sharpening.

Smart Stroke Painting and Smart Settings

The Sharpen palette appears. Accept the default settings and click OK.

Go To FILE>SAVE AS and rename the image **rose_auto_FIN.jpg**, if you want to save the Auto Painting.

With Auto-Painting, it's amazing how many options are available with the simplest of choices. Explore these automatic settings and try them out in a variety of ways.

In the top of the Auto-Painting palette, there are two boxes that can be enabled for Smart Stroke Painting and Smart Settings.

Smart Stroke Painting applies paint strokes that follow the forms in the photo.

When Smart Stroke Painting is selected, it is important to watch the painting and stop it yourself. It does not know when the painting is "done," unlike Smart Settings

(see below). To STOP the painting process, touch the stylus to the tablet or press the red STOP button, which is grey and unusable until the Play button is started.

NOTE: Smart Stroke Painting will randomly paint the image with the brush variant chosen. If the image appears to be painted with one color, then stop the painting process, go to the Color palette, and depress the Rubber Stamp to ensure it's set on Clone and not set for painting.

Smart Settings can only be enabled after first clicking Smart Stroke Painting. The two must be used together. Smart Settings was originally designed to be used with the category Smart Stroke Brushes. It was quickly determined that almost any brush can be used with Smart Settings, which makes this option even more powerful and interesting.

Smart Settings starts out covering the canvas with large brushstrokes, no matter what size brush is chosen. The brush will get progressively smaller on its own and bring in more detail that it intuitively finds in the image. On this setting, it knows when to stop by assuming it has found and painted all the details. Watch this setting and wait for it to finish or you can choose to stop it yourself at any point with the STOP button.

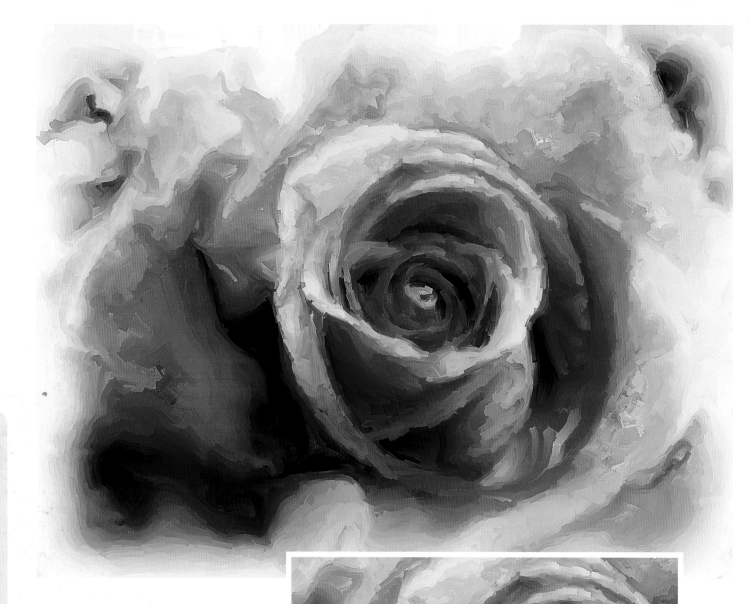

The same rose was painted again in the Classical Intense Color version with these two boxes clicked. Painter intuitively follows the photo to create a painting.

Here is the result of the Smart Settings:

Clone Painting

The creative power of Painter X lies in its variety of clone painting options. Here's how it works at its most basic: Cloning copies image information from a source image and replicates it in the image you are painting on. There are two distinct types of Clone painting, Clone and Quick Clone.

When using Clone painting, an exact duplicate is created to paint on; this copy uses the original image as the Clone source.

Quick Clone places a blank canvas over the image that appears as Tracing Paper. This can be accomplished in two ways. The first is to go to FILE>QUICK CLONE. Or you can use the QUICK CLONE button in the Auto-Painting palette, just like we did in the last lesson. The Tracing Paper that covers the image can be toggled on and off to paint onto the blank canvas.

Clone Painting is one of those things that's much easier to show than describe, so let's jump right into a short lesson. You'll see how Clone Painting works at the end of this example, where we'll pull detail back into the painted image using brushes.

To start Clone painting, go to FILE>OPEN, select **rose_ORIG.jpg**. Then go to FILE> CLONE.

After choosing CLONE, you should now have two identical images open. The only difference is that one says "Clone of" in the Document Title bar. You'll work in the "Clone of" version, so click on it to bring it forward, if it's not already.

Next, we'll begin painting the image. Choose the brush: CHALK / LARGE CHALK.
SIZE: 60 OPACITY: 100%
GRAIN: 23%

Press the Rubber Stamp in the Color Wheel to use the brush as a Cloner.

Go over the entire image using the Chalk to break all of the rose's de-

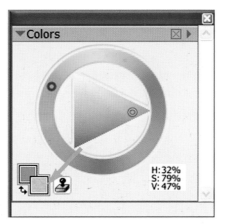

Click the Rubber Stamp to switch between using brushes for cloning or laying down paint.

tailed edges so they look less realistic and more painterly.

Press the Rubber Stamp again to add color (notice the Color Wheel is bright again).

Now add color to the image.

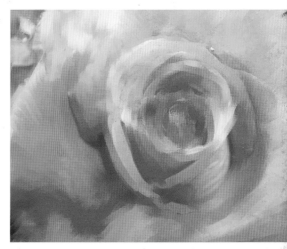

The rose is now starting to look more like a painting and less like a photograph.

Use the DROPPER tool to select colors from inside the painting. Once a color is selected it appears in the Color palette, and you can further adjust it with the Color Wheel. This will give you a variety of color choices to add to the painting that are similar, but not identical to, the colors already there.

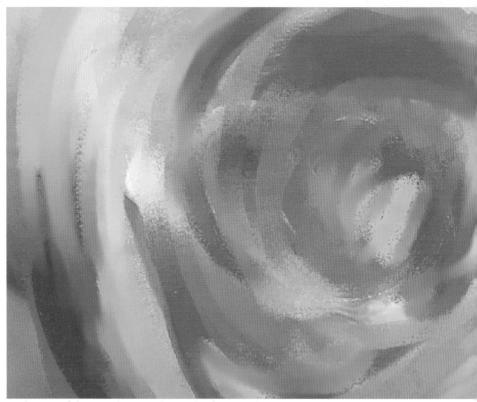

A close-up of the rose showing the result of using Blender brushes.

Select the BRUSH tool. It should still be set on Large Chalk.

Change the SIZE to 18 and lower the OPACITY to 50%.

Continue painting with the chalk to blend colors into the image.

Change brush sizes for a varied look.

After the colors are added, use a Blender brush to smooth them in.

Choose the brush: BLENDER/ JUST ADD WATER.

SIZE: 20 OPACITY: 20%

Brush with strokes that pass through at least two colors so that they can be blended together to look natural in the image.

If you're feeling adventurous, try some of the other Blender Brushes for different effects like GRAINY WATER or RUNNY.

Now choose the brush: CLONER / SOFT CLONER.

SIZE: 20 OPACITY: 12%

Click the Rubber Stamp in the Color palette to use the brush as a Cloner.

Follow the contours of the rose with the brush to bring back the edges of the image. Using the brush as a Cloner allows us to bring back details from the original picture in areas that might have been over-painted.

When you are pleased with the way the rose looks, add some sharpening to pop the texture of the brushstrokes.

Go to EFFECTS>FOCUS>SHARPEN. The Sharpen palette will appear; leave all settings to their defaults and click OK.

If you over-sharpen, then go to EDIT>FADE to turn down the effect.

You can leave the setting at the default 50% or experiment to see what works best for you.

Go to FILE>SAVE AS, and rename the file **rose_01_clone.jpg**. Using 'clone' at the end describes how it was painted. The '01' denotes this is your first version. Both of these will help you quickly recognize what was done to the file without opening it.

Now the finished painting should be looking good. With a basic understanding of Clone Painting, we're now ready to move on to more advanced Cloning.

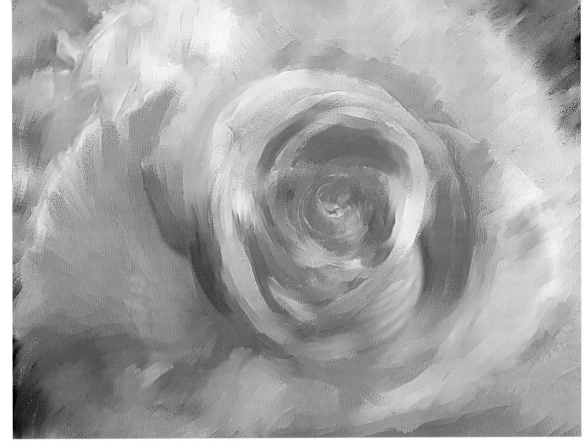

The finished painting using the Clone method.

Trouble Shooting

There are some basic problems that often pop up when working with Painter X for the first few times. Here are the solutions:

Problem: In Auto-Painting, no matter what brush you choose it keeps going back to a Smart Stroke brush.

Solution: Start the habit of choosing the brush after clicking Smart Stroke Painting and Smart Settings. If the brush is chosen before, the program automatically selects the Smart Stroke category for a brush.

Problem: While clone painting, all I am getting is gray and not the colors from the clone source, or when Soft Cloning all I see is a gray flower pattern.

Solution: Oops! You forgot to CLONE your image. Check FILE>CLONE SOURCE and you will probably see that there is only the image open with no "clone of" copy, or the selection is set to "Current Pattern" which draws the information from the Pattern Palette.

Problem: Every time I try to paint there is a message that pops up that says "Only Watercolor brushes can be used on watercolor layers" or "Non-Liquid Ink brushes cannot be used on Liquid-Ink layers."

Solution: Somewhere in the painting process a watercolor brush or liquid ink brush has been used. Check the layers palette and there will be a layer there that was added when one of these brushes was used. Use DROP from the LAYER COMMANDS icon menu or from the main menu LAYERS>DROP ALL. This will flatten the layers and once again any brush can be used on the painting.

Painting from Multiple Clone Sources

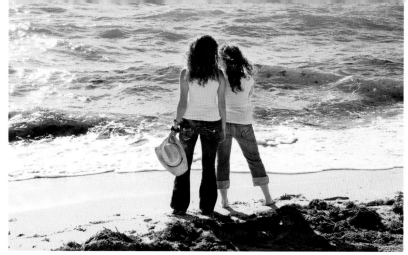

The original file before painting or Cloning begins.

Understanding Clone sources is the most important feature of Clone painting. Sometimes, when I paint, I might be working with a dozen or more sources. These are all images that are open in Painter and available to use, but are minimized. In this lesson, we're going to take an image of two girls on a beach and alter it by making many different versions to Clone from. By making several different versions of the image, each with a specific area (like the ocean or sand) we like, we'll be able to sample these parts into one final image incorporating the best of all the versions.

NOTE: This lesson will use the NIK Filters and Snap Art plugins. If you have not already installed these programs, do so now. For more information on plugins, see page 13).

The first step is to create an image with more hue and saturation.

Go to FILE>OPEN, select **girls_beach_ORIG.jpg**.

Go to EFFECTS>TONAL CONTROL>ADJUST COLORS.
The Adjust Color palette opens.

From the USING drop down menu, choose IMAGE LUMINANCE.

Push the SATURATION slider up until your painting has richer colors. Try about 55%.

Now SAVE AS with the file name **girls_beach_ORIG_HS.jpg**.

We have added the HS in the file name as a reminder that it is the Hue and Saturation that have been altered in this version.

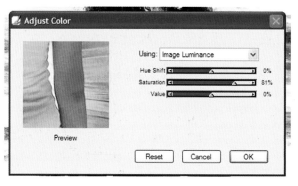

The Adjust Color palette, where the Saturation can be altered.

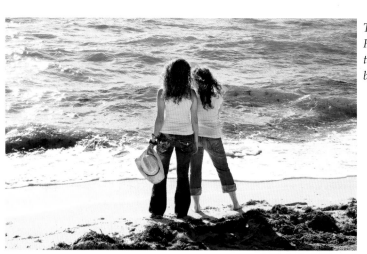

The image after the Hue and Saturation changes have been applied.

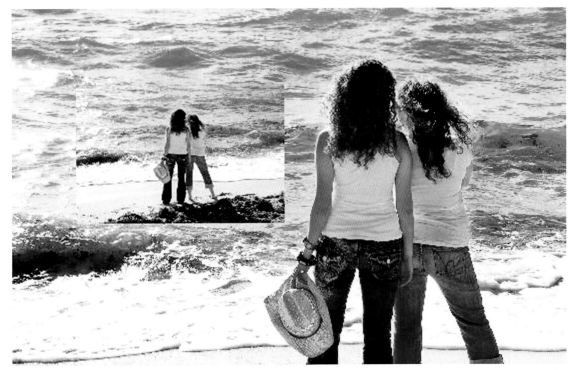

The Hue and Saturation have been changed in the Adjust Colors palette compared to the original image .

Using the **girls_beach_ORIG_HS.jpg**, we will create another version of the image to use as a Clone source.

If we evaluate the water, we see that it could be made more interesting if the texture and color were changed. If the image has more whites in it, it will appear less photographic than how the ocean looks now. We'll use plugin filters to make this change.

Open NIK filters on a PC by going to EFFECTS> NIKSOFTWARE> COLOR EFEX PRO.

On a Mac, open NIK as a plugin in the graphics program it was installed in.

The NIK interface opens; select MONDAY MORNING from the alphabetical list on the left.

On the right, click the drop down menu palette and select MONDAY MORNING BLUE; your image should show the applied filter.

SAVE AS; **girls_beach_water.jpg**.

Minimize this image. All images being used in the final painting need to be kept open in Painter but they can be minimized. Only images already open in Painter can be used as Clone sources.

The NIK plugin interface. The filters are easy to find in the alphabetical list on the left side of the screen.

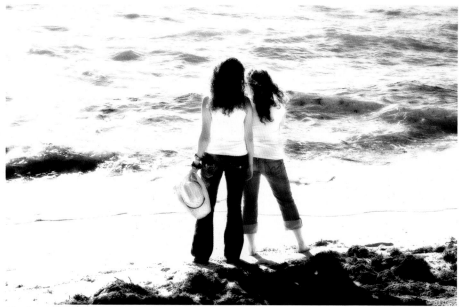

The image after the Monday Morning Blue filter has been applied.

Now let's turn our attention to the sand. It could be more interesting as a source to Clone from. Let's use the Snap Art plugin.

FILE>OPEN the **girls_beach_ORIG_HS.jpg** file, if it's not already open.

Open Snap Art either from the EFFECTS menu (PC) or the graphics program it is installed in (Mac).

Go to EFFECTS>SNAP ART>PASTEL and ZOOM IN on the sand on your screen.

Then choose the CANVAS tab from the left of the screen and change it in the drop down menu to NONE.

The Canvas tab options. Select None.

The Snap Art interface shows a split screen offering an image preview.

After clicking OK, SAVE AS with the new name **girls_beach_pastel.jpg**.

Then go to FILE>OPEN **girls_beach_ORIG_HS.jpg** again.

Three images should now be open in Painter, **girls_beach_water.jpg**, **girls_beach_pastel.jpg**, **girls_beach_ORIG_HS.jpg**.

Go to FILE>CLONE SOURCE and all three file names should show up.

The three open files can be used as Clone source

Now we can choose which file to work with and switch back and forth between them.

Bring forward or maximize the **girls_beach_ORIG_HS.jpg** version. Go to FILE>CLONE.

You should now be working in a version named "Clone of girls_beach_ORIG_HS.jpg."

Go to FILE>CLONE SOURCE, select the file **girls_beach_water.jpg** from the drop down menu. It will now be the Clone source.

The Art of Digital Photo Painting: Using Popular Software to Create Masterpieces

Choose the brush: CLONER /
SOFT CLONER.
SIZE: 85 OPACITY: 12%

Paint over the ocean until it looks
similar to the **girls_beach_water.jpg**.
The Soft Cloner brush doesn't
apply any brushstrokes, it just
pulls the image information in
from the Clone source.

Now paint the ocean with a paint-
ing brush.
Choose CLONERS /
BRISTLE BRUSH.
SIZE: 30 OPACITY: 40%

Paint the ocean using horizontal
strokes that mimic the feel of
waves. Use varied brush sizes for a
better effect.

Once the background water is
painted, SAVE AS with the new
name **girls_beach_bkgrd.jpg**. Al-
ways remove "Clone of" from any
file name, otherwise the files will
be harder to identify and find later.

Still working in **girls_beach_bkgrd.jpg**,
we'll begin painting the girls and
their details by going to
FILE>CLONE SOURCE; select
girls_beach_ORIG_HS.jpg.

At this point, we'll take advantage of
a little Auto-Painting in a selection.

Select the LASSO tool. (The Lasso
tool is stacked under the Square
Marquee tool, which is just below
the Brush in the Toolbox.)

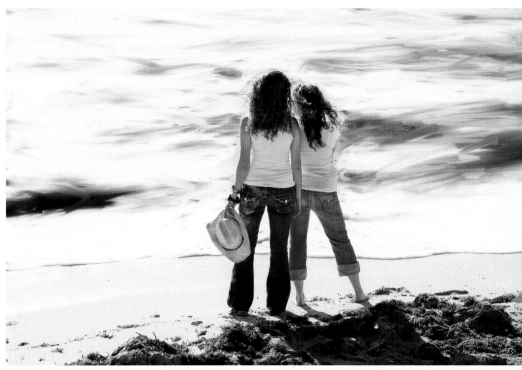

The image after the Bristle Brush has been used.

Make a loose selection around the
girls. This does not need to be a
tight selection around the bodies; it
can be a loose one for painting. Be
sure to completely encircle your
subject with the Lasso or Painter
will finish the selection for you—
often in a way that doesn't look right.

The dotted, moving line you now
see is the selection; often, digital
artists call this line "marching ants."

This selection should be feathered
to have a softer edge.

Go to SELECT>FEATHER; in the
Feather Selection palette, change
the setting to 10 Pixels.

Choose the brush: ARTISTS / SAR-
GENT BRUSH.

SIZE: 32 The other brush settings
remain at their defaults.

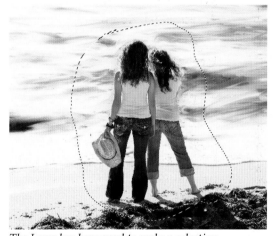

*The Lasso has been used to make a selection
around the girls.*

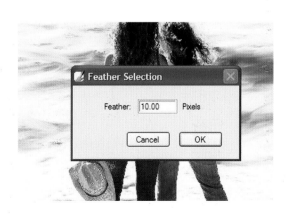

Check the Color palette to be sure the Rubber Stamp is clicked for Clone painting.

Using the Auto-Painting palette, click on the STROKE drop down menu, change it from SCRIBBLE LARGE to SHORT DAB.

Click the PLAY button to start the painting.

Click the STOP button when it looks painterly enough for your tastes.

This effect is looking really great, so much so that we should do the whole painting this way.
First, we need to Invert the selection so it will now paint the background.

Go to SELECT>INVERT.

The Clone source also needs to be changed back to the water version.

Go to FILE>CLONE SOURCE> girls_beach_water.jpg.

Press PLAY to start the Auto-Painting.

As it plays, the separation between the girls and the water will be less and less obvious.

Press STOP when the painting looks good.

Use hand brushstrokes with the same brush to paint through any edges

around the girls that look like they missed being Auto-Painted.

Change the CLONE SOURCE to the girls_beach_pastel.jpg file.

Choose the CLONER / SOFT CLONER brush again. Use the same settings as before.

Brush along the bottom of the image to bring in the painted sand.

SAVE AS with the name girls_beach_paint_01.jpg.

Choose the brush: CLONER / BRISTLE BRUSH.
SIZE: 15 OPACITY: 40
Change the Clone source to the version girls_beach_ORIG_HS.jpg. Very lightly paint back shape onto the girls' arms, bodies, and hat so they are defined.

The painting now has a Monet feeling to it, but needs a little more detailing to be finished.

It needs Sharpening so the brushwork stands out.

Go to
EFFECTS>FOCUS>SHARPEN.

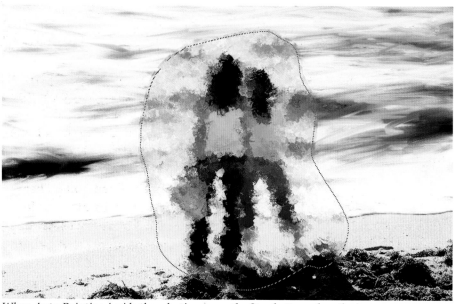

When Auto-Painting inside the selection, press the Stop button when the image looks similar to this painting.

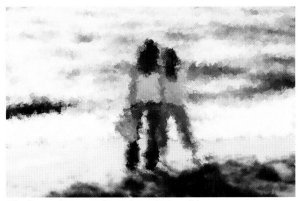

The image has now been Auto-Painted in-side and outside the selection, and the sand has been Cloned in from the pastel version.

Accept the default settings in the Sharpen palette and click OK.

Also turn up the contrast by using EQUALIZE.

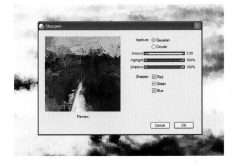

Go to EFFECTS>TONAL CON-TROL>EQUALIZE.

Accept the default settings in the Equalize palette and click OK.

If the effect is too strong, go to EDIT>UNDO, then go back to the

The final image looks interesting thanks to Painter's ability to Clone in sections of different images into one final painting.

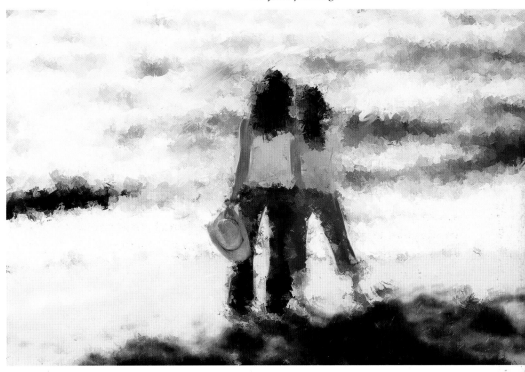

Equalize palette and move the black and white points to the outside.

SAVE AS with the new name **girls_beach_paint_FIN.jpg**.

While I painted the background twice with two different brushes, this is not unusual. The layering of brushwork over and over is not only possible, but wonderful for adding more dimension and depth to paintings.

Clearly, your Clone sources can be varied and many. Also, usually be-fore any painting is started, it's usually a good idea to sit and eval-uate the image and play with a number of sources using a variety of software and methods. Then open them all in Painter and let your creativity take over. Some may never be used as the painting evolves, but they are there to spark ideas and give many op-tions for painting.

4

Easy Portrait Painting

Portrait paintings have a huge variety of styles, from classical to Pop Art to Impressionist, plus many more. The more Classical portrait paintings involve a tremendous amount of detail, which we'll learn how to do in the next chapter. In this chapter, we'll jump right in to painting portraits in a variety of techniques that are fast and easy; later, these can be combined with more details to take them to the next level.

Traditional Portrait Painting

The first consideration in a portrait painting is to decide on the style desired. Learning to paint a traditional portrait first is a stepping stone to a variety of portrait painting techniques, so we'll start there.

Go to FILE>OPEN, choose **teen_girl.jpg.**

This is the original image we'll use to create a traditional portrait painting.

Open the Auto-Painting palette by selecting WINDOW> AUTOPAINTING.

Click the QUICK CLONE button, found in the bottom of the Underpainting palette. A new duplicate image will now appear, covered by the tracing paper.

Click the SMART STROKE PAINTING and SMART SETTINGS buttons in the Underpainting palette.

Choose the brush: ARTIST OILS / BLENDER BRISTLE.
SIZE: 40 OPACITY: 50% RESAT: 0%

Be sure the Rubber Stamp is clicked in the Colors palette so Clone painting is selected.
Hide the image so the screen is white by clicking the TOGGLE TRACING PAPER icon.

Click the PLAY button at the bottom of the Auto-Painting palette to start. Let the Auto-Painting play until it's finished.

Select the BRUSH and start to hand paint on the girl's skin and hair to smooth it. Follow the lines of her facial features and the lines of her hair with long, smooth strokes.
Be sure to ZOOM IN to be able to see your work.

The Blender Bristle brush responds well to being made smaller for details and larger for hair. Lift the brush often off the canvas to create lots of brushstrokes.

Turn off the Rubber Stamp in the Color palette so you can use the DROPPER tool to pick up some color from the image. Use the DROPPER to select color from the face, then adjust the colors in the Color palette so they are slightly different than the ones already on the canvas. Continue painting the skin. Adding additional colors will add depth to the painting.

Now use the DROPPER to select colors from the eyes; tweak the colors slightly in the Color palette. With the brush, add these colors to the eyes. Adjust the brush size for these smaller areas, and lift the brush often so it will refill with paint each time.

Some of the shadow areas could be a little darker, so the Burn tool will be used.

Don't feel the need to paint over the entire canvas. Just do enough to smooth things out. Less detail means the image looks less like a photograph and more like a painting.

Select the BURN tool, which is stacked under the DODGE tool in the Toolbox.

Use these settings: SIZE: 50 OPACITY: 3% JITTER: 0%
Use the Burn tool to make shadow areas under her chin, in her hair, and on the background darker. In particular, her hair needs burning to bring back texture.

At this point, the painting should be ready for the finishing touch, which will tone down the brushwork and enhance the colors. The EQUALIZE effect will do all of that at once.

Go to EFFECTS>TONAL CONTROL>EQUALIZE.

The Equalize palette will appear. Accept the default setting by pressing OK.

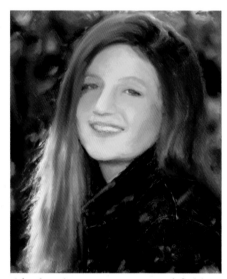

After burning, you can see more definition in the hair.

Use the Equalize palette to enhance the colors in the painting.

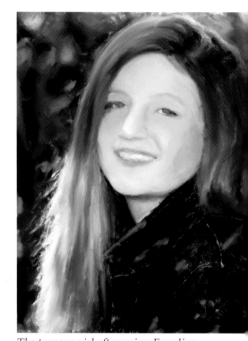

The teenage girl after using Equalize.

It's clear to see that the Auto-Painting feature in Painter is an easy and efficient way to begin a painting, but the hand brushstroke is still an important artistic touch necessary to create a work that does not look totally Auto-Painted.

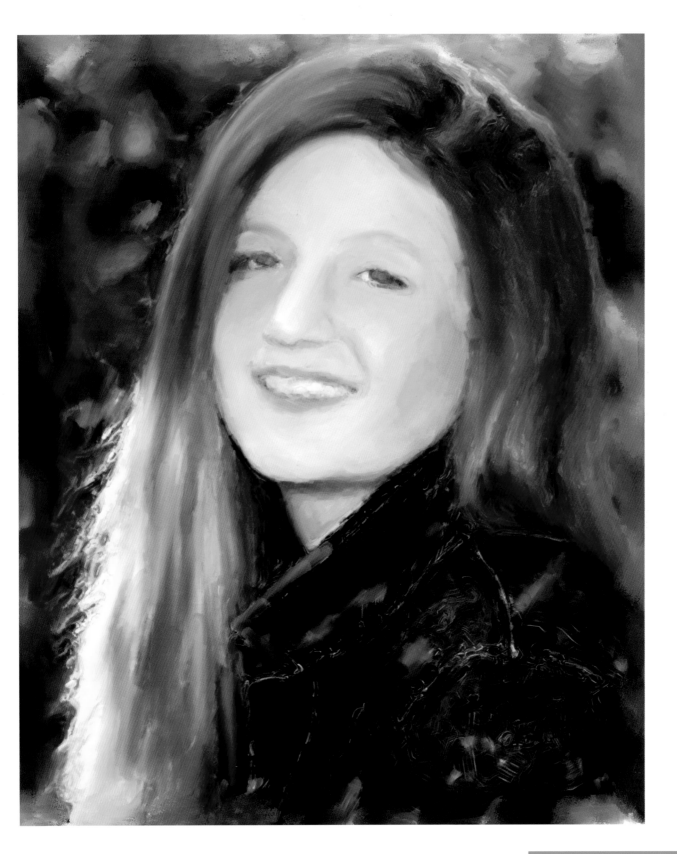

Sketch Effects Portrait Painting

Blending a sketch effect with a painting can create a beautiful finished product. With the software available, this is easy to do and still have it look totally hand painted. We'll be using TwistingPixel's ArtStudioPro software in this lesson, so if you don't already have the software or a trial version installed, do so now (see page 13 for more information on software).

Open TwistingPixel's ArtStudioPro.

In ArtStudioPro, go to FILE>OPEN, choose **shawl_ORIG.jpg.**

At the top of the screen, there is a choice between ADVANCED or BASIC buttons.
Choose ADVANCED so all the controls will be available.

From the Menu bar, choose FILTER>ARTSTUDIOPRO CLASSICO, and then choose the filter DAVINCI below it. A preview of the filter will appear on the screen.

Notice the SHADE COLOR is set to a dark brown default. Change that color by clicking on the brown box and move it to a warmer color.

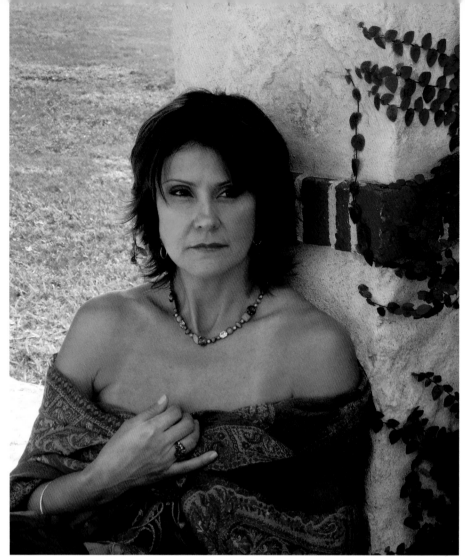

By using other software, and not just Painter X, we'll turn this portrait into a really interesting painting.

Click on the brown box to bring up the Color Picker palette.

Select the color with the slider on the right, then adjust the hue by clicking inside the box. Another option is to use the RGB settings found in the right of the palette to change the color.

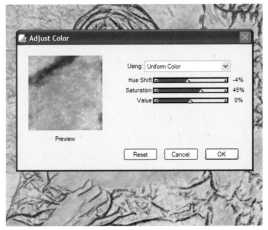

Settings for Hue and Saturation.

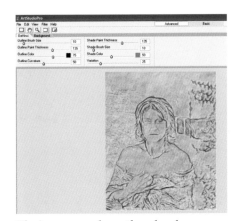

The image now shows the color change.

The program will render the image after you save the file.

In order to prepare the sketch to be used in the painting, it needs a bit of tweaking. First, the color needs more contrast.

Go to EFFECTS>TONAL CONTROL>ADJUST COLORS.

The Adjust Color palette appears.
Watch the preview window as the Saturation is increased and the Hue slider is moved; be sure a warm tone is achieved. Click OK.

Next we will sharpen the image.
Go to EFFECTS>FOCUS>SHARPEN.
This will open the Sharpen palette.
Bump up Sharpen a bit from the default of 3.0 to around 4.4.

Next, go to FILE>SAVE AS and give the painting the new name **shawl_sketch.jpg**. Save the image to the folder you've created for this project. The program now starts rendering the image.

We're done with ArtStudioPro, so you can now close it. The image will close, too.

Open the **shawl_sketch.jpg** in Painter.

Also open the original file **shawl_ORIG.jpg** that the sketch was created from.

Bring the **shawl_sketch.jpg** file to the front.

If you decide afterwards it was sharpened too much, go to EDIT>FADE and turn down some of the Sharpening.

FILE>SAVE again and it will over-write the last file saved so now the image is both color corrected and sharpened. This is one of the few times SAVE will be used instead of SAVE AS. Normally we don't want to overwrite the image, but in this case we want to start painting with the color corrected version.

Now the fun and creativity begins. These two images, the original and the Davinci sketch, are the ingredients to endless paintings. Let's do a few different versions to get the idea of the process, and then you will want to try out different styles for yourself.

Bring the **shawl_sketch.jpg** image forward, if it is not already.
Go to SELECT>ALL, then EDIT>COPY.

Now bring the **shawl_ORIG.jpg** image to the front.

Go to EDIT>PASTE IN PLACE (this assures it is pasted on the file in the same orientation it had before).

Now there are two layers in the layers palette. Adjust the OPACITY slider to lower the intensity of the top layer.

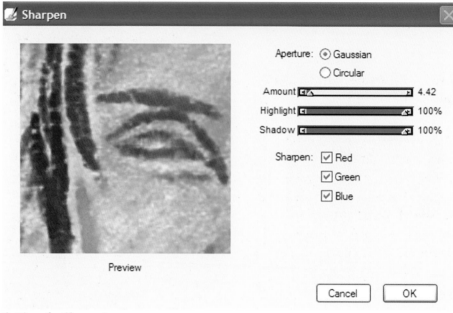

Settings for Sharpening.

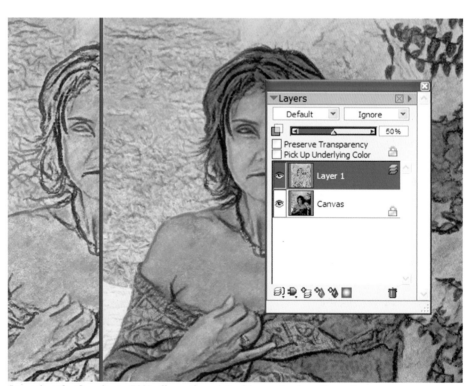

Lowering the Opacity to 50% allows the original image to show through.

When it looks good to you, flatten the layers by clicking the LAYER COMMANDS icon, the first icon on the far left in the bottom of the Layers palette. Choose DROP from the menu. This flattens the layers into one image.

SAVE AS with the new file name
shawl_sketch_01.jpg.

The next step requires the same process to blend two images together, but instead of using the original image, we will Auto-Paint the **shawl_sketch_01.jpg** and create a new base layer for the Davinci sketch to go over.

Bring the **shawl_sketch_01.jpg** image forward.

WINDOW>SHOW UNDER-PAINTING.

In the Auto-Painting palette, click QUICK CLONE and have SMART STROKE PAINTING and SMART SETTINGS clicked.

Click the TOGGLE TRACING PAPER icon to hide the image.

Choose the brush: SPONGES / SMEARY WET SPONGE 60.
Set it as a Clone brush by clicking the Rubber Stamp in the Color palette.

Click the PLAY button to start the painting, but this time press STOP before it finishes.

Bring the **shawl_sketch_01.jpg** image forward.

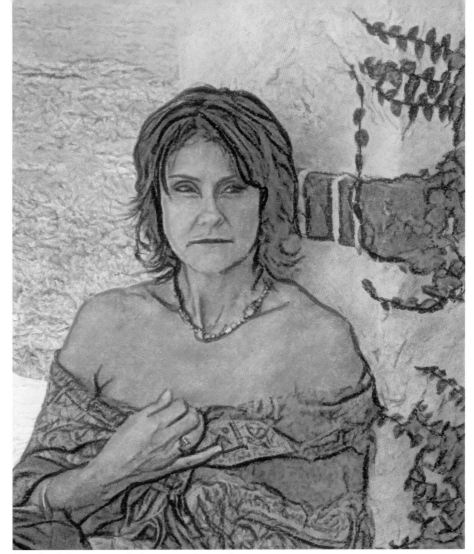

The sketch image once the layers are flattened.

Auto-Painting should be stopped when the image looks similar to this.

Copy the file and then paste it on top of the Cloned version we just Auto-Painted, and lower the Opacity.

Decide when they look smooth and gently blended, and then DROP the layer.

SAVE AS with the new name **shawl_sketch02.jpg**.

The image now shows the combined layers for an interesting effect.

The last step (if you want to stop here) is to use Equalize to create a powerful painting now combining all the ingredients together.

Go to EFFECTS>TONAL CON-TROL>EQUALIZE.

Accept the default settings in the palette and click OK.

SAVE AS with the new name **shawl_sketch_FIN.jpg**.

If you want to try other options, a good place to start would be to create new Auto-Paintings with a variety of brushes and see how they work with the Davinci sketch overlay.

Second, go through the Layers Composite Methods in the Layers Palette and try each one of them to see the changes the painting will go through.

Once Equalized, the colors really pop and the painting is done.

Always remember to use FILE>SAVE AS and give all your paintings new names for important steps and for the final image. A painting that seems wonderful today may not be your favorite in a few weeks. By saving multiple steps, you'll be able to go back and see the choices you made and choose different settings for a new final painting.

Watercolor Fast Portrait Painting

Watercolor paintings are usually very difficult to replicate digitally, but with this technique, it would be very hard to tell the difference once this image is printed on watercolor paper.

Go to FILE>OPEN, choose **watercolor_ORIG.jpg**.

Go to FILE>CLONE.

Choose the brush: BLENDERS / WATER RAKE.
SIZE: 28 OPACITY: 26%
GRAIN: 26%

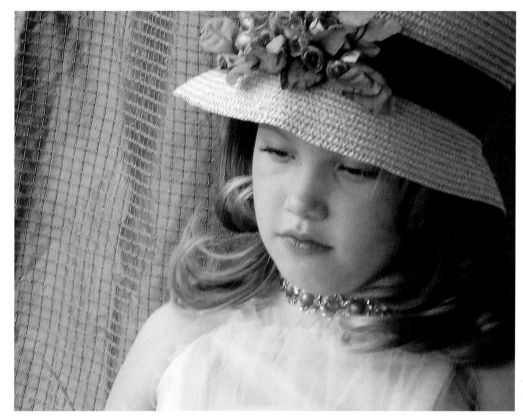

The original image we'll use for fast watercolor portrait painting.

After using the Water Rake brush, your image should look somewhat like this.

Use short strokes in all directions to totally cover the image.

Go to FILE>SAVE AS, rename the file **watercolor_rake.jpg**.
This is the new base for the painting.

Now take the original image and do an Auto-Painting, but this time use a brush category that was designed by Corel to work with the Smart Stroke Painting and Smart Settings.

Go to WINDOW>UNDERPAINTING.

Click the QUICK CLONE button and then the TOGGLE TRACING PAPER icon to hide the image.

Select the SMART STROKE PAINTING and SMART SETTINGS in the Auto-Painting palette.

Choose: SMART STROKE BRUSHES / WATERCOLOR BROAD
SIZE: 8.5 OPACITY: 29% GRAIN: 40%

Press PLAY to start the Auto-Painting. Let it paint until it stops by itself. The painting will still need some small touchups, so take the brush in hand. Touch up the skin where the watercolor effect bled into edges of the subject. Concentrate on the subject only and not the background.

The image after Auto-Painting and hand painting.

Go to FILE> SAVE AS, save with the new name **watercolor_auto.jpg**.

Three images should now be open in Painter. The one that was Auto-Painted with the watercolor brush (**watercolor_auto.jpg**), the background painted with the water rake (**watercolor_rake.jpg**), and the original photograph (**watercolor_ORIG.jpg**).

Bring the **watercolor_auto.jpg** image forward.

Go to SELECT>ALL, then EDIT>COPY.

Bring the **watercolor_rake.jpg** image to the front.

Go to SELECT>PASTE IN PLACE.

After using the Eraser tool, the Rake painting starts to show through. Make this as detailed or as messy as you like.

This will place the Watercolor painting on top of the Water Rake background.

Select the ERASER tool.
SIZE: 100 OPACITY: 20%

Gently erase the background enough to blend the two layers together into one smooth painting.

Check to see if a little EQUALIZE would be helpful to saturate the colors.

Go to EFFECTS>TONAL CONTROL>EQUALIZE. Use the defalt settings and press OK.

When finished, go to FILE>SAVE AS with the new name **watercolor_FIN.jpg**.

Now you have a basic understanding of how to do quick, easy portrait paintings in a variety of techniques. Good creative paintings don't always need to take a lot of time. In the next chapter, we'll go into more advanced and detailed techniques that will build on the skills learned in this chapter.

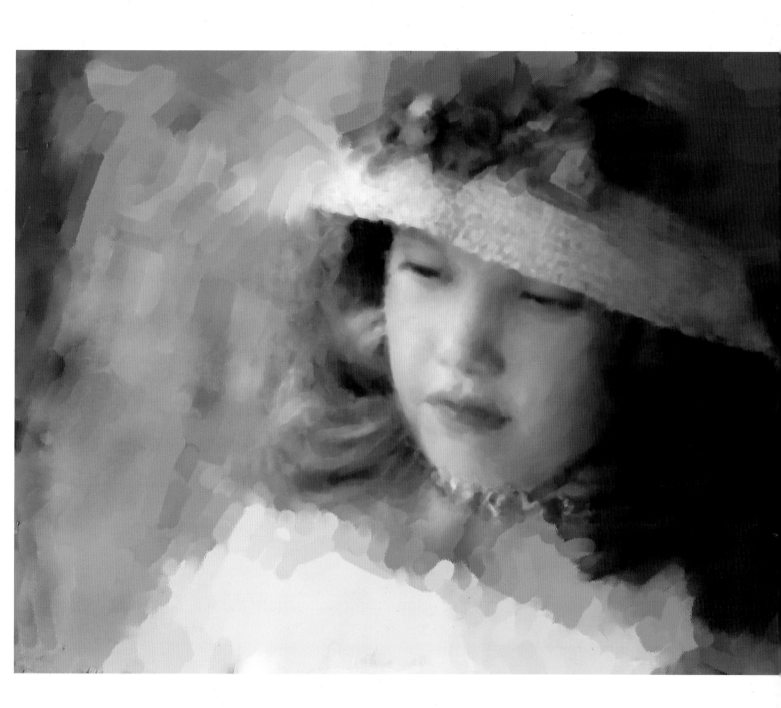

gallery

Suzanne Clem-Wheeler

www.portraitsbysuzanne.com

Suzanne is a sensitive and caring portrait artist located in Atlanta, Ga. When she learned there was software available for the professional artist that defied all boundaries of traditional painting, she began practicing with a stylus instead of a brush and has a loyal following that treasures and collects her paintings.

" I find a peace in my heart when creating a portrait sitting by orchestrating nothing... Merely a casual conversation, a whispered suggestion here or there, singing silly made-up songs to elicit the unprepared smile; these are my mastered tools. This is my art. This is how I create art that happens to be you."

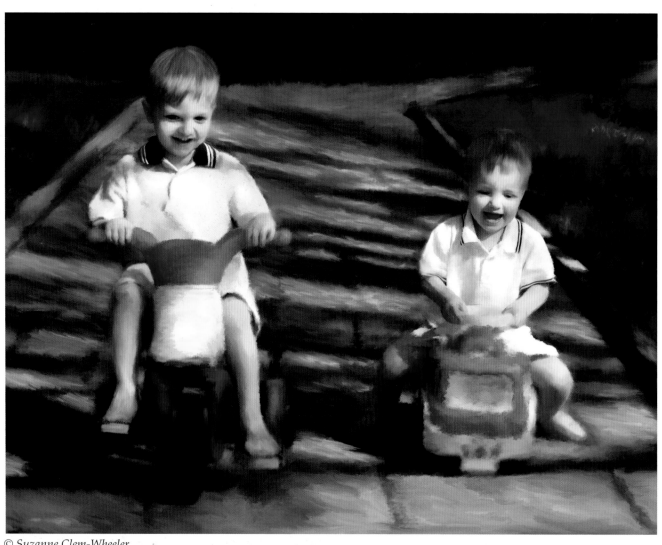

The Art of Digital Photo Painting: Using Popular Software to Create Masterpieces

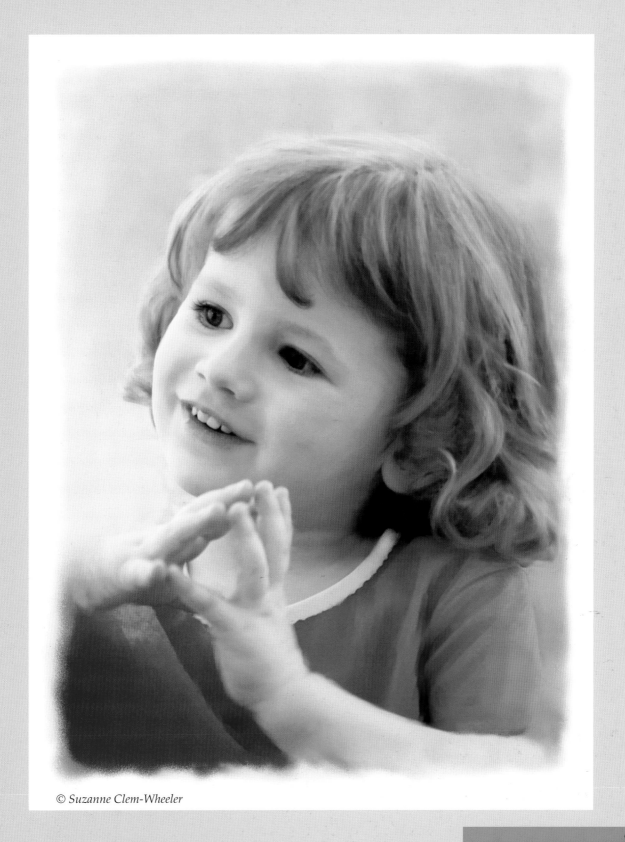

© Suzanne Clem-Wheeler

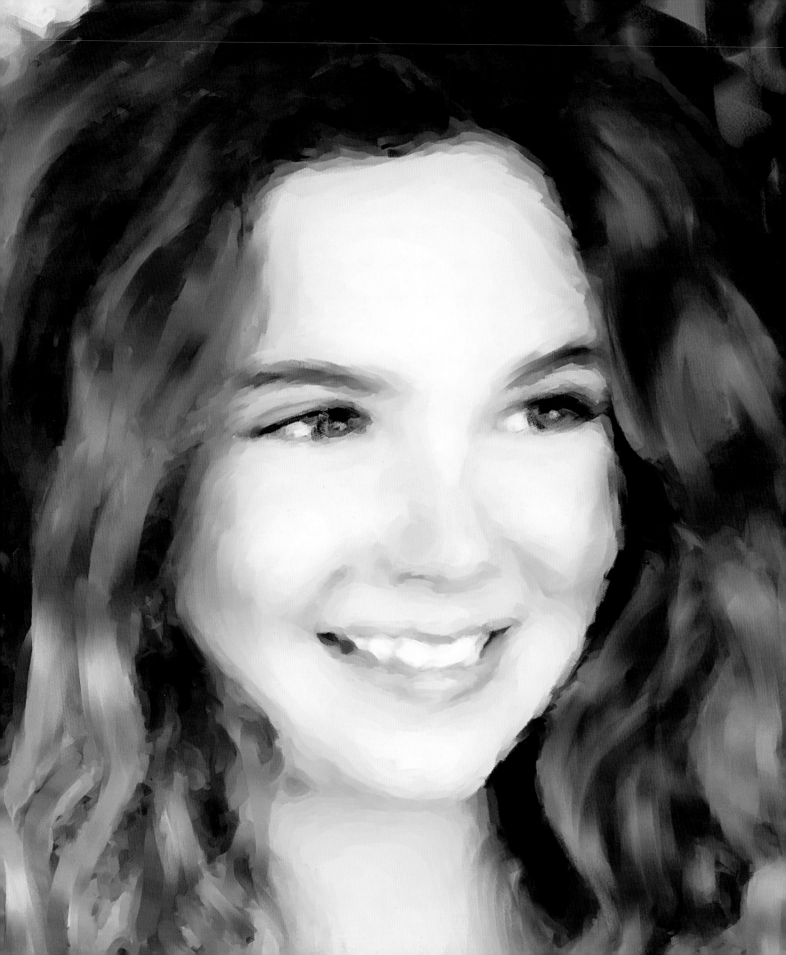

5

Painting People

Painting people is challenging, but with practice and the right brushes and tools, it can go quickly and produce some of the most rewarding results. Those new to digital painting often want to know how to paint skin, hair, and eyes. This chapter is going to explore the different ways to do this, but always remember that there is no "one and only" way. As you get more comfortable with Painter, you will explore other methods to make portraits, and you will be able to pick and choose what works best for you and your type of brush-strokes. Therefore, in this chapter, we won't be saving the various steps of the paintings as we go along. We'll explore a variety of ways to get portrait results, and you can save the ones you like best. When finished with the chapter, you can revisit the styles that worked best for you and complete the whole image by combining what you have learned.

Since this method of painting skin is done on a layer, we can control the Opacity of the layer and paint a little messier and faster.

Chose the brush: ACRYLICS / CAPTURED BRISTLE.
SIZE: 20 OPACITY: 50% RESAT: 0%

By setting the Resat to 0%, we are using the texture of the brush but not adding any paint.

ZOOM IN on the painting, otherwise the brush size will be too small to use.

Click the Rubber Stamp in the Color palette so the Captured Bristle brush is now a Cloner brush.

Now add a layer in the Layers palette by clicking the third icon from the left, which is the NEW LAYER icon.

Painting children is a pure joy—their faces are beautiful, round, and expressive. And since almost everyone has a child in their life they would like to try painting, working with a picture of a child is a great place to start learning to paint people.

Tip: When painting detailed areas like hair, skin, and eyes, it helps to zoom in on the area you are focusing on. Be sure to zoom out occasionally to see how the effect looks at the image's actual size.

Open the image in Painter; go to FILE>OPEN **redhead_ORIG.jpg**. Choose FILE>CLONE.

For this project, the painting will be done on a layer.

If the Layers palette is not open, go to WINDOW>SHOW LAYERS. Do not add a layer yet.

If the Color palette is not open, go to WINDOW>COLOR PALETTES>SHOW COLORS.

Painting Skin on a Layer

There are two ways of thinking about skin in paintings. One is to have the smoothest skin possible and the other is to show brush-strokes and painting texture. For children, it usually works best to try for the smoothest skin to reflect their gentleness and purity of nature.

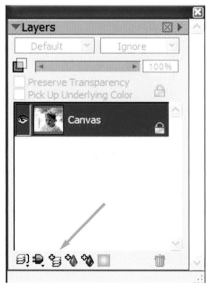

Click the New Layer icon to add a layer.

Lastly, check the box PICK UP UNDER-LYING COLOR in the Layers palette. Now you are ready to paint.

Click the icon next to a layer to turn it off; this makes the layer invisible until the box is clicked again.

Note how smooth the skin appears now compared to the original image.

Begin painting the skin of your subject and follow the contours of the face.

To see just your brushstrokes, click the icon next to the Canvas layer in the Layers palette. This will turn off visibility for the Canvas layer, leaving only the layer you are working in visible.

After painting, click the icon again for the Canvas layer to turn it on, if needed, and lower the Opacity in the Layers palette until the skin appears flawless and smooth. Usually the setting ends up between 70–80%.

Once you are happy with the look of the painting, click the LAYER COMMAND icon in the Layers palette (this is the first icon on the left). Select DROP to flatten the image.

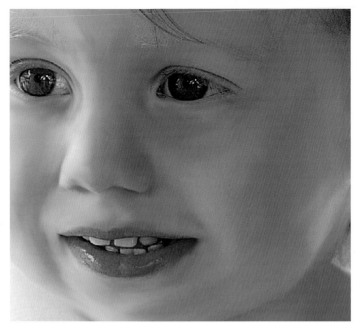

Painting Skin with Blender Brushes

Painting skin with blender brushes is an ideal way to get smooth skin as well as achieve a painterly look. To experiment with these ways to paint skin, open **redhead_ORIG.jpg** and try these Blender brushes to see the different results. The first step in all of the following examples is to FILE>CLONE the ORIG file, so you don't make the mistake of overwriting the original file. For painting skin, all of the Blender brushes will look best if the Opacity is between 20–50%.

After using the Round Blender Brush, the skin becomes smooth like porcelain. There should be few obvious brushstrokes since this is a smoothing brush.

BLENDERS / ROUND BLENDER BRUSH 10

SIZE: 15 OPACITY: 50% RESAT: 0%

Begin to paint the subject, following the contours of the face. Notice that the skin now has a painterly quality and has more brushstrokes showing than the Captured Bristle brush method.

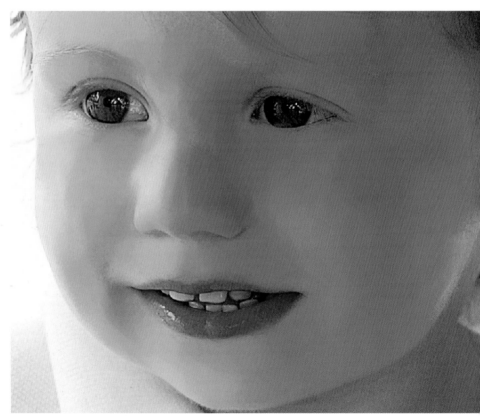

Blending using the Grainy Water brush.

BLENDERS / GRAINY WATER

SIZE: 20 OPACITY: Between 20%–40%

Blending using the Soft Blender Stump brush.

Tip: To paint lips and teeth, try using the same brush chosen for the skin, only at a smaller size and using a lighter touch.

BLENDERS / SOFT BLENDER STUMP 20
SIZE: 25 OPACITY: 40%
With the Soft Blender Stump, use a light hand on the tablet and notice that the shadows are dragged a little into the highlight areas to create a "blocky" looking painting.

BLENDERS / JUST ADD WATER
SIZE: 20
Turn down the Opacity to 40% and be sure to use a light hand on the tablet with this brush.

Blending using the Just Add Water brush.

Painting Skin for Strong Textures

The brushes that come with Painter are a great assortment, but there are also many free downloads of brushes available on the Internet. One of the most popular sets of brushes that are free to download are Den's Oils Brushes. Denise Laurant is a wonderful artist who designed this set of brushes years ago, and they have been circulating around the world creating amazing art. You can visit her site at: www.thepainted-cat.co.uk/on-the-easel. The most famous brush is Den's Funky Chunky, but the entire set of brushes is great.

NOTE: These brushes can be downloaded for free with the directions for installing them into Painter X at www.digital-paintingshop.com. Choose the 'Freebies' tab for the free downloads.

In this example, the Oil Funky Chunky brush was used as a Cloner, and it created lovely tones. It is best used at a smaller size and with a short back and forth stroke. The lips and teeth were also painted with the same brush used at a very small size.

Painting Hair

Painting hair is not as hard as it seems at first. The main elements to consider are texture, detail, and color. All hair also has highlights and lowlights giving the shadow areas depth and texture. Beginner painters often make the mistake of over-blending the hair and losing all texture and detail. Paint the hair until it looks rich and has texture and still retains some of the detail.

Cloner Blended Method

Many of the brushes work great for painting hair in a blended method when used as Cloners. Each one of these brushes has a different finish to its brushwork. Try out a few different brushes before deciding which one to use, and also mix them up in the same image.

When painting, be sure to follow the lines of the hair and not go against them. For each brush below, use long, light strokes on the hair and go over it multiple times until the hair no longer looks photographic. Open the **redhead_ORIG.jpg** each time you experiment with a new brush. ZOOM IN to at least 50% to see your work close up.

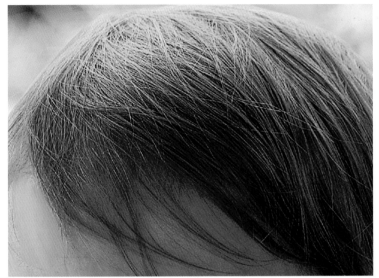
A child's hair before being painted with various methods.

Hair painted with the Bristle Brush Cloner.

We'll do a few examples:

Select the brush: CLONER /
BRISTLE BRUSH CLONER.
SIZE: 15 OPACITY: 72% RESAT: 57%
Practice with the brush and close the
file without saving.

Hair painted with the Oils / Variable Round brush.

Select the brush: OILS /
VARIABLE ROUND.
SIZE: 19 OPACITY: 63% RESAT: 99%
Set the brush to Clone by pressing
the Rubber Stamp in the Color
Palette.

Hair painted with the Acrylics / Captured Bristle brush.

Now try the brush: ACRYLICS /
CAPTURED BRISTLE.
SIZE: 20 OPACITY: 50% RESAT: 0%
Setting the Resat to 0% will allow
the brush's shape and format to be
used without laying down any
color at all because Resat controls
how much paint is on the brush.

The hair after burn and dodge are applied.

Adding Highlights and Lowlights to Hair

Adding highlights and lowlights will give more depth to hair. The three finishing touches that accomplish this step are to Burn, Dodge, and Glaze.

The Burn and Dodge tool are stacked in the Toolbox; click and hold on the tool showing and the flyout menu will show both tools.

Click and hold the Dodge tool icon to reveal the Burn tool underneath.

Choose the BURN tool.

Using the Burn tool at only 3% Opacity, use a large brush and paint over general areas, giving more depth and texture to the hair. Do not cover the entire head.

Select the DODGE tool; apply 3% Opacity to paint in some light areas.

As the finishing touch, select the brush: OILS / GLAZING FLAT 30. SIZE: 30 OPACITY: 5% RESAT: 40% Use the DROPPER tool to choose a color brighter than the actual hair color, and use a light touch and sweep on the glaze following the direction of the hair. Don't cover the entire head—just add a light layer of color.

These methods all create a rich palette of hair color. Hair should never be one color but a varied mix; otherwise, it will look very unnatural.

To choose a color for the glaze, use a color already in the hair and tweak it to be darker or lighter.

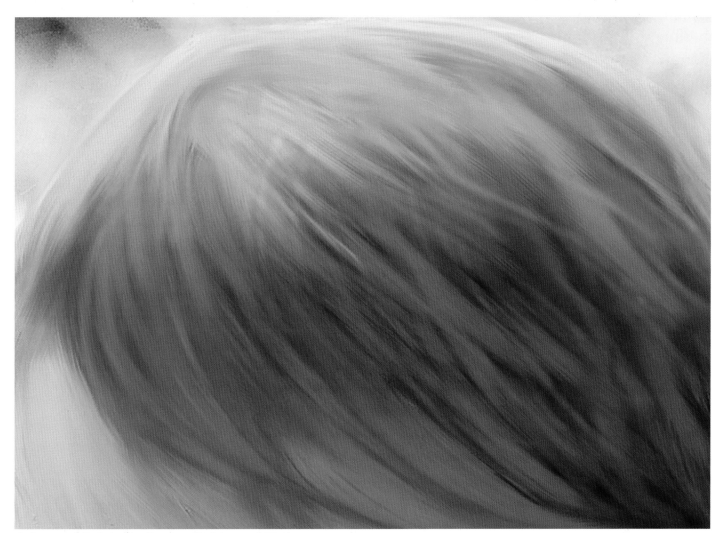

A close-up of the hair after Burning, Dodging, and Glazing.

Painting Eyes

Painting the eyes in photographs and portraits is a struggle for many photographers who have been trained to always have highlights and sharp eyes in their photos. With painting, the rules all change—highlights are definitely not sharp and the eyes can lack detail. By studying eyes in many paintings, it's easy to see that there is a lot of variation, from the vaguely suggestive to the very detailed. Eventually, you'll develop your own style that will change from painting to painting, depending on the effect you're trying to achieve. The methods I have devised for painting eyes are my own and reflect my style of painting. Learning these first will give a good basis for painting eyes from photographic references.

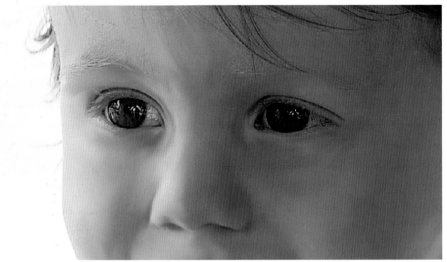

A close-up of the eyes before painting begins. Zoom in close so you can see your work.

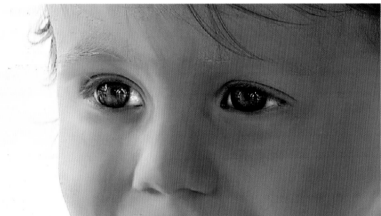

After the Burn and Dodge tools are used, the highlights and shadows have become more defined and there is more detail.

Painting Detailed Eyes

Just like with painting skin, it pays to learn how to paint detailed, traditional eyes first.

Then, after this lesson, we'll be able to try more painterly effects and create what I call Messy Eyes.

FILE>OPEN **redhead_ORIG.jpg**. ZOOM IN so we can see both of the eyes close up.

To begin, select the DODGE tool; set the Opacity to 3%.

Use the Dodge tool to clean out the eye whites and lighten the eye color.

Choose the BURN tool; set the Opacity to 3%.

Use the Burn tool to burn in the eyelashes and the shape of the eye by going around the entire eye. Then burn in the black outline of the iris.

Now it's time to add color to the eyes by painting small splashes of color. A painting should reflect the real eye color but not be the actual color. Saturating and enhancing the color is what separates paintings from photographs. Choose a color either with the Dropper inside the eye and then change it slightly to a stronger color in the same family or use the Color palette alone and choose a color from it.

Choose the brush: ACRYLICS / CAPTURED BRISTLE.

SIZE: 10 OPACITY: 50% RESAT: 60%

Add a few dabs of color into each eye. Wherever a color is painted into one eye, the same should immediately be painted into the second so they match.

Now add a second color in the same family, but make it darker or lighter. Finally, add a third color that is for what I call "punch" to give the colors life.

Next add a little bit of white around the eyeball, but do not fill the entire white area. To keep the shape of the eye when we are blending, leave some of the outer area gray (see image below).

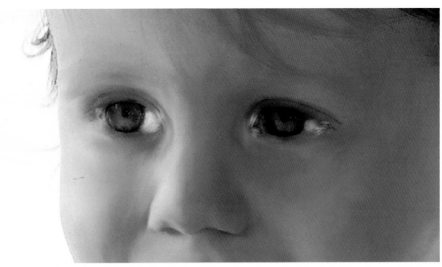

The eyes have been Blended with the Grainy Water brush, and a bit of pink has been added with the Captured Bristle brush.

Select the brush: BLENDERS / GRAINY WATER.

SIZE: 6.5 OPACITY: 20%
GRAIN: 80%

Blend through the colors and into the white of the eye and around the entire eye. Blend in the direction of the eyelashes and the crease in the eyelid.

Go back to ACRYLICS / CAPTURED BRISTLE.

Add a little pink to the eye corners and blend again with the GRAINY WATER brush. This adds warmth, dimension, and life to the eyes (see image above).

After blending, the eyes may look a little flat, but we have an excellent fix for that.

Select the brush: PHOTO / SATURATION ADD.

Make this brush the exact size of the iris (leave the other settings at their default) and it will saturate the colors back to brilliance. Click and hold the brush over the iris, and move it to the left and right slightly to apply the saturation.

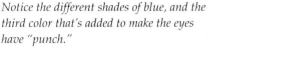

Notice the different shades of blue, and the third color that's added to make the eyes have "punch."

When moving the brush side to side, don't leave the outline of the iris.

Lower the Opacity on the new layer after the Fairy Dust brush has been used.

Our last step is to add back in some highlights.

Add a layer to the painting in the Layers palette by clicking the NEW LAYER icon.

Choose brush: F/X / FAIRY DUST.

SIZE: 13 OPACITY: 80%

RESAT: 100%

Using white paint on the new layer, add a little bit of fairy dust to the eyes. Lower the Opacity on the layer until it looks muted (see above), and then DROP the layer.

Go to FILE>SAVE AS and rename the file **redhead_eyes_traditional.jpg**; don't close the painting because we'll use it in the next step.

The detailed version of painting the eyes is now finished; next we'll learn to make things a little more impressionistic.

Painting Messy Eyes

Painting Messy Eyes starts where the lesson on Detailed Painting left off. After the traditional eyes have been saved, CLONE the file.

There are two brushes I like to use for the next step. One is my own MARILYN EYE SMUDGER, which is a free download at the Digital Painting Shop (www.digitalpaint-ingshop.com), and the other is

DENS OIL BRUSH MESSY (also a free download at the same site) with the Opacity set at 0%.

The first step of the process is to smudge or mess the eyes with one of the brushes just mentioned (see image below).

Choose the brush: CLONER / SOFT CLONER.

SIZE: 6.4 OPACITY: 12%

Use the brush to bring back original detail from the clone source to the eyes—but not too much; we still want them messy! That is why we cloned the finished detailed painting of the eyes—it is now the clone source to bring back details (see image at top right).

Play with these traditional and messy methods until it feels and looks right for your own paintings. Most of my portrait paintings are now a mix of these two methods.

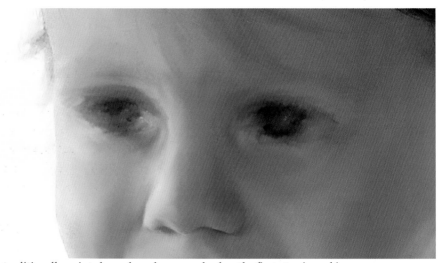

The traditionally painted eyes have been smudged as the first step in making them more impressionistic.

After Cloning, the eyes still have detail, just not as much as the traditional painting.

The effect of adding and Cloning color with the Square Conte brush.

Painting Painterly Eyes

Paintings leave a lot to the viewer's imagination by letting the mind fill in the missing details. By using less details and more paint, we can achieve this effect with the eyes we work on. By using the Conte brush category, a more painterly brush-stroke is put down and lightly blended so they eyes are less finished, which lets the imagination fill in the details.

Go to File>OPEN the **redhead_ORIG.jpg** file.
Go to FILE>CLONE.

Choose the brush: CONTE / SQUARE CONTE 15.
SIZE: 5 OPACITY: 20%
GRAIN: 12% RESAT: 100%

If you are uncomfortable with the color strength, lower the RESAT to 50% or less (that was not done for this example).

Add color covering the entire eye and to the lower lid and the eyebrow area.

The painting process for this brush is to add and blend color at the same time. To do this, click the Rubber Stamp ON to set the brush for Clone and OFF to add color.

Add a new Layer using the NEW LAYER icon in the Layers palette.

Add eye highlights using the same brush but on the new layer to take

advantage of the Opacity control, which should be lowered to around 80%.

After you are satisfied with the results, DROP the layer.

To paint the eyebrows and smaller areas that need blending, choose the brush: ACRYLICS / CAPTURED BRISTLE.
SIZE: 10 OPACITY: 50% RESAT: 0%
ZOOM OUT often to see the effects taking place.

Don't expect to be an instant expert at painting eyes. It's rare to get perfect results painting eyes the first time (or the first 50 times). Keep practicing with all the methods and experimenting–in time it will become natural.

Now eye highlights have been added with the Square Conte brush and the eyebrows have been painted with the Captured Bristle brush.

Painting Clothing

Painting clothing is a process of adding color and blending it. Color needs to be added to the clothing to give it depth, and photographic edges need to be painted over. It is a relatively easy process and can be fun to experiment with it.

Go to FILE>OPEN, select **redhead_ORIG.jpg**.
Go to FILE>CLONE.

Start painting by going over the entire clothing area with the Blender brush:
BLENDERS / ROUND BLENDER BRUSH 10.
SIZE: Vary from 10 to 30
OPACITY: 50% RESAT: 0%

Notice that the details were blended through. The buttons and logo on the shirt are not important in the painting. The logo is completely blended into the shirt and the buttons are blended to just a hint of the button color to leave the rest to the imagination.

Also notice that the bulky part of the shirt on the upper right shoulder has been thoroughly blended. It needs to be painted into the background to truly disappear.

To paint it into the background, the same brush will be used but the RESAT setting will be changed to 60%. Once that is done, the same Blending brush will lay down

The clothing has been blended with the Round Blender brush. The logo and buttons are painted through and the edges of the clothing have been smoothed.

color. Using the DROPPER, choose color from the background near the problem area and begin painting with the brush now loaded with paint.

Leave the brush on this setting to add color to the shirt that will be blended.Using the DROPPER, choose some complementary colors for the painting. This stark white shirt could use some warming up to keep the general feeling of the painting so the colors we choose will be from the warm colors in the painting. Good places to choose the color from are the hair, the lips, and the skin.

Paint the darker hues of the paint in the shadow areas and the lighter hues in the highlights.

Return the RESAT setting on the brush to 0% and begin blending in the direction of the paint strokes just enough to soften and blend the colors in, but not so much that they disappear entirely.

Clothing is always best painted by following the contours of the cloth-ing and noticing the shadows and highlights and emphasizing them. Adding color emphasizes the shape of the clothing and how it drapes on the body. No matter what the cloth-ing is, it should be enhanced with color and blending and not show very much detail.

This close-up shows the bulky part of the shirt has been minimized by painting over it and blending it with the background.

Color has been added to the shirt to help warm it up.

Now we've learned various ways to paint detailed portrait paintings. The final painting created by combining some of the techniques to paint hair, skin, and eyes is a beautifully finished work of art. Now that you've tried a number of techniques yourself, go back and select your favorites and combine them to make your own final painting. As a last step, the background on this painting was simply blended to keep it soft and diffused. The subject is the main focus in this painting and nothing should detract from him.

Painting people doesn't have to be difficult. Instead of trying to stay within the confines of the photo reference, let your imagination and brush strokes stay loose and fluid. Allow the painting to take shape so that it has a life of it's own, and its not just a colored facsimile of the reference photo. The further you go away from the painting to have it no longer look like a photograph, the better a painter you will become.

Brush Tips

There are many brushes in Painter and it can get a little confusing at times. This section is a reference to remind you of specific information about some of the brushes and which ones work well for different projects.

Acrylic / Captured Bristle

This magical brush is one we use constantly. It is wonderful for laying down color.

Take the RESAT down to 0% and it's an awesome Blender.

Use this brush on a layer to paint skin as well.

Blenders / Grainy Water

Take the Opacity down on this brush to 20% or 40% and it will do a great job on anything you need blended. It also works well on skin and eyes. If you apply color with the Captured Bristle brush, this is a good brush to blend it with.

If the Resat is raised from 0% to a higher number, it will also lay down color in a watery way—very nice.

Blenders / Soft Blender Stump 20

Using this brush on skin gives a very soft, smooth finish—almost like an airbrush. Also, the Resat can be turned up to lay down gentle color.

Cloners / Soft Cloner

The ultimate "No Mistakes" brush. Set it to 10% Opacity to Clone from your original photo source to correct mistakes, or any source to Clone in a different image. This brush only paints from the source image—it has no brushstroke.

Cloners / Bristle Brush Cloner

This is a nice brush that blends hair well without losing detail. It works best when the Opacity is lowered.

This is also a good brush to use for Auto-Painting using the Scribble Large stroke.

Cloners / Camel Oil Cloner (not the IMPASTO version!)

This popular brush gives an oil-painting look. Try it on hair, backgrounds, and clothing. Play with the Opacity to bring in just the right amount of information from the Clone source.

Charcoal / Charcoal

A good brush for laying down textured color.

Chalk / Square Chalk

Play with this for Auto-Painting by turning it into a Cloner. It works quickly and has a lot of grain and texture, which makes the Auto-Paintings look more like actual paintings.

Calligraphy / Thin Smooth Pen 10

This is what I use to hand sign my paintings, but I make the brush size much smaller.

Oils / Smeary Bristle Spray

This is a great brush and you will love the texture. Use this brush for hair, but set it as a Clone brush to bring in some of the original texture.

Oils / Glazing Flat 30

This is the brush used to bring in highlights and "icing" at the very end of the hair painting process. It can also be used to add depth of color. Use it with the Opacity very low, between 5–8%. While this adds color, it does not change the brush strokes under it.

Photo / Saturation Add

A good brush to pump up the color in eyes, lips, and anywhere you need to not add a brushstroke but just add saturation to the colors.

gallery

Cat Bounds

www.pbase.com/catbounds

I first noticed Cat Bounds artwork on digital art sites years ago. Her work is fresh and her approach is always original. Her artwork reflects her soul and experience as an artist. I always enjoy seeing her new work, as she is full of surprises.

Cat Bounds has won numerous digital art competitions, including the 2006 Corel Photo Art Master contest. She is a lifelong artist and has been doing digital art for about 2 years. She is currently doing commission work in digital media.

"In Song Sung Blue, *I began with pencil scribbles, using the cloned image as a guide. Then I blended everything to give it a softer, almost dream-like quality. My art is about an emotional connection with the subject and about color; I chose a color palette that added to the glow, as if the guitar player were surrounded by city lights.*

Ballet Rouge. © Cat Bounds

Ballet Rouge *is a favorite of the paintings I've done for photographer Richard Calmes because he says I captured the essence of the ballet. I worked the background in shades of red, using a variant of Jeremy Suttons custom brush: MishMashScumble. I tried to emphasize the fluid nature of the dancers' clothing and bodies.*"

Song Sung Blue. © Cat Bounds

Painting
Vibrant Color

Painting with color involves learning a little
bit about color itself. Understanding some
of the color fundamentals will not only help
in choosing colors to paint with, it will also
make you view colors differently. In this
chapter, we'll get into some of the tricks
that can be used to find and use colors fast.

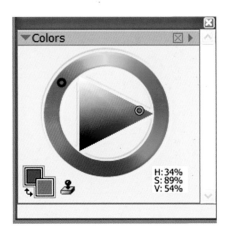

The Painter Color palette.

Understanding Color

Warm Colors and Cool Colors

Color creates passion and emotion. Once, while driving on the Palisades Parkway in New Jersey at the height of the autumn colors, I started crying. It was an emotional experience to be inside all that color. It just moved my heart and soul to be inside it.

Warm colors are vivid, brilliant, and energetic. Warm colors are derivatives of orange, red, and yellow.

Cool colors are calming, feel natural, and can be soothing. Cool colors are derivatives of blue, green, and purple.

Analogous Color: Colors that contain a common hue and are found next to each other on the color wheel, e.g., violet, red-violet, and red create a sense of harmony. Adjoining colors on the wheel are similar and tend to blend together well.

Complementary Color: Two colors opposite one another on the color wheel, e.g., blue and orange, yellow and purple, and red and green. Intensity can be altered by mixing a color with its complement, which has the effect of neutralizing the color. Changing the values of the hues, or adding black or white, will soften the effect.

Those are the two basic ways we deal with color in painting and it's easy to see which colors are next to each other and which ones are across from each other in the color wheel on the Color palette.

Adjusting Colors Before Painting

It's often a good idea to change the colors of an image before you start painting. This way you'll have nice, saturated colors in your painting as you work. Even if starting with a relatively bland photograph, you can turn it into something that sings with color rather quickly.

For example, this photograph of acorns and leaves will quickly be changed into other versions that will be painted with vibrant colors.

To begin, go to FILE>OPEN, select **acorn_ORIG.jpg.**
Go to EFFECTS>TONAL CONTROL>ADJUST COLORS.
The Adjust Colors palette will come up. Change the drop down menu to IMAGE LUMINENCE and put the cursor over the preview window until the little hand shows up. Move the image in the preview window to an area that will best show color changes.

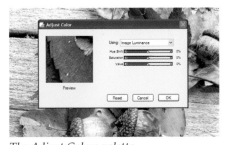

The Adjust Colors palette showing a preview.

Move the SATURATION slider all the way to the right and watch the color in the preview box change. Click OK and the image changes color.

This image shows the variety of colors that can be achieved once the Saturation is raised and the Hue is changed.

Bring up the Adjust Colors palette again.

This time move the HUE slider back and forth to see the color changes, then pick one and click OK. Make multiple versions with a variety of colors, then decide which one you want to keep and paint.

Go to FILE>SHOW UNDERPAINTING. Click QUICK CLONE and select SMART STROKE PAINTING and SMART SETTINGS.

Choose the brush: ARTISTS / IMPRESSIONIST.

Make sure the brush is set as a Cloner in the Color palette by clicking the Rubber Stamp.

Press PLAY; let the Auto-Painting finish.

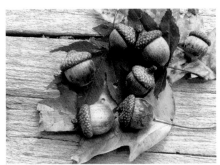

The Saturation has been raised using Image Luminance.

The color change difference is even more apparent once the image is Auto-Painted.

After using Equalize, the colors really pop and sparkle.

Often after painting, it appears that the colors are muted or they are lacking in contrast.

To saturate the colors, go to: EFFECTS>TONAL CONTROL>EQUALIZE.

The Equalize palette appears. Leave the default settings; press OK.

Use the Equalize palette to saturate the colors after painting.

By using the Sharpening palette, the details become more clear and finalized.

The last step after analyzing the painting is to sharpen it.

Go to EFFECTS>FOCUS>SHARPEN.

The Sharpen palette now appears. Use the default settings and press OK.

SAVE AS **acorn_FIN.jpg** and this painting is done.

A close-up of the acorns after Sharpening.

One Painting, Many Different Moods

Everyone has different psychological associations with color. To emphasize this, let's paint one image in a series of steps. Take time to study each one and examine your feelings about the painting. Just to compare, we'll start with the original photographic colors and then alter the picture step-by-step. Now you can feel the powerful effect of different colors.

Step One: The original woods image.

Step Two: The woods image Auto-Painted in original colors with the Conte / Dull Conte 8 brush.

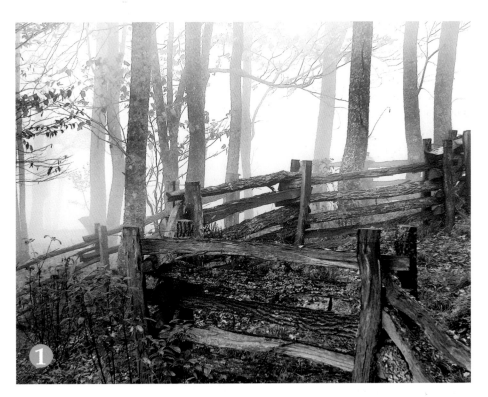

Step Three: The woods image has undergone a change by using the default Equalize settings. No Hue or Saturation changes have been made yet.

Step Four: The woods image is richer and brighter by going to Tonal Control>Adjust Colors. The Saturation was increased in the Adjust Colors palette.

Step Five: The woods image is desaturated and only gray, black, and white are used.
In Tonal Control>Adjust Colors, The Saturation is pushed totally to the left end of the slider to desaturate the image.

By comparing the images, note how the feeling and emotion suggested by each is changed depending on its color and saturation. Whenever you finish a painting, it's a good idea to explore your color options. Be creative and examine your emotional response to each color change.

One Painting, Many Different Colors

A wonderful choice for decorating a wall is to put a grouping of paintings together that are all the same image shown in different colors. Each color can be complementary to the rooms décor. This is a simple task to do in Painter by using the power of the Hue slider to change the colors.

Starting with an image of dull leaves, we will paint it into a variety of rich colors.

Go to FILE>OPEN, choose **leaves_ORIG.jpg**.

First we will brighten the leaves and improve the contrast with Equalize.
Go to EFFECTS>TONAL CONTROL>EQUALIZE.
Accept the default settings in the Equalize palette; click OK.

Next the image needs a little Sharpening to pop the details.
Go to EFFECTS>FOCUS>SHARPEN.
In the Sharpen palette, set the AMOUNT to 10.

The original image of the leaves is a bit dull, but that can be fixed.

The Equalize settings improve the contrast in the picture.

Sharpening has been applied to the leaves to make the details clearer.

Once again the leaves need to be richer, so use a little more Equalize; however, this time we'll make a change to the default setting.
Go to EFFECTS>TONAL CONTROL>EQUALIZE.

With the Equalize box opened, move the left triangle-shaped slider, found just below the graph, towards the right.

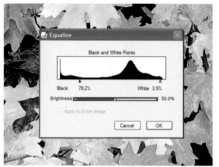

Move the left slider towards the right.

The resulting picture is now a far richer image to start the painting process with.
Go to FILE>SAVE AS **leaves_01.jpg**.

We now have a good color corrected file we'll use to paint from.

Go to FILE>CLONE.

Paint the leaves in the Auto-Painting palette; click the QUICK CLONE button, and select SMART STROKE PAINTING and SMART SETTINGS.

Choose the brush: CLONERS / IMPRESSIONIST.

Make sure the Rubber Stamp is set to Clone.

Press PLAY; let the painting finish.

Then SAVE AS with the name **leaves_02.jpg**.

Now we can create our own set of various colors of the same painting.

Go to EFFECTS>TONAL CONTROL>ADJUST COLORS.

In the Adjust Colors palette, move the slider back and forth to watch the colors change in the preview box.

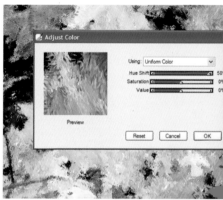

You can change the painting's color in the Adjust Color Palette.

Auto-Painting has given the leaves an impressionist look.

When you see a color you like, click OK.

FILE>SAVE AS with the name **leaves_color name.jpg**. (Note: name the file with the actual color you have chosen, like **leaves_yellow.jpg**, for example.)

Now there are many identical paintings, but the colors are wildly different! This is an easy way to create groupings of paintings and decorate a room.

A variety of colors can easily be made using the Hue slider.

Match Palette Paintings

There is a feature in Painter X called Match Palette, which lets you borrow the colors from one image and apply them to another. To change an image's color, you can open an image that features your desired color scheme and use the Match Palette effect to apply the new color scheme to your image.

Here are a few ideas for how to use Match Palette: Create your own palette of colors laid down on a new canvas, use a previous painting you've made, or even use a painting that's not yours whose colors you admire.

We'll use Alien Skin Snap Art in this lesson. Download the trial version of this program if you haven't done so already (see page 13 for more on software.).

Go to FILE>OPEN, and select **brushes_ORIG.jpg** and **acorns_painted.jpg**.

The Art of Digital Photo Painting: Using Popular Software to Create Masterpieces

We'll change the color scheme of this brushes image by matching the color palette of the acorns.

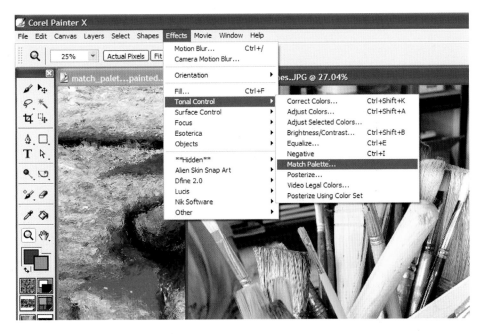

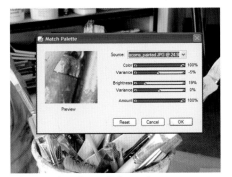

The Match Palette dialogue box.

Make sure the **brushes_ORIG.jpg** image stays in the front for the next step.

Go to EFFECTS>TONAL CONTROL>MATCH PALETTE; the Match Palette dialogue box now opens.

First be sure the SOURCE is the painting you want to get the colors from. In this case, that's **acorns_painted.jpg**.

Set the COLOR PERCENTAGE to 100%; this tells Painter how much of that color to use. VARIANCE will affect the brightness of that color. Lower this to -5%.

BRIGHTNESS will determine how light or dark the color match will be. Set this to 19%. VARIANCE is giving another option for controlling the brightness; leave it to the 0% default.

Set the AMOUNT to 100%; this is the overall control for the entire effect combining the brightness and color.

Click OK. The picture of the brushes should now look similar to the acorns in color.

OPEN Alien Skin Snap Art as a plugin in Painter.

(If using a Mac, open Snap Art as a plugin in your preferred graphics program.)

Go to EFFECT>ALIEN SKIN SNAP ART>COLORED PENCIL.

The Alien Skin interface now opens. Select the SETTINGS tab.

Choose the preset ABSTRACT COLORFUL.

The screen is divided into before and after images by using the Preview Split Screen.

Snap Art offers image preview in a split screen interface

The picture of the brushes has now matched the acorn painting's color palette.

The brushes image now shows the Colored Pencil effect applied in Snap Art.

In the MENU tab, go to CANVAS, change the setting to NONE.

Click OK. The image opens in Painter with the effect applied.
(For Mac users, save the file as a .jpg and reopen in Painter.)
Now SAVE AS **brushes_01.jpg**.

The full effect of the match palette isn't evident until Equalize is used.
Go to EFFECTS>TONAL CONTROL>EQUALIZE.
The Equalize palette appears. Accept the default settings and press OK.

To finish, SAVE AS **brushes_FIN.jpg**.

Using Match Palette is a quick way to change the entire color scheme of your painting in one step. And by applying a filter from a plugin, painterly affects can be achieved with little effort. In examples like this one, we can see that using a combination of plugin software and Painter X brings out the best in both programs to bring different art elements together into one painting.

In digital painting, as in all art, color is paramount. It is expressive and influences your viewers emotions and reactions to your work on obvious and subtle levels. Using the skills learned in this chapter, you now have the ability to understand and control colors in Painter to make them express your creative intentions.

Looking at the Match Source on top of the finished painting, it's easy to see how closely they now relate in color.

gallery

Chris Price

www.studiochris.us

Chris Price is an inspirational digital artist and illustrator whose work exudes bright color and a mastery of digital art creation in Corel Painter X and the Adobe Creative Suite of applications. His playful and creative use of the software stems from a background of traditional art and never being afraid to try new techniques that push the creative envelope.

Painting My Best Friend (detail). © Chris Price

Painting *My Best Friend*

This painting is a special one for Chris because it features his best friend since childhood. The painting was created using a mix of techniques from photo reference in Painter X and was featured in Issue 8 of Corel Painter *Official Magazine* with a short tutorial. The entire piece was painted with the Painter's Oil Pastel 20 brush from the Pastels brush category using varied size, opacity, resaturation, and bleed settings. Colors were gradually built up and given their final punch through multiple layers, much like a traditional painter uses washes of paint. The final piece was printed on artist-quality canvas and embellished using many traditional painting materials and techniques.

Going Beyond Digital

The final print of *My Best Friend* features several additions that are not digital! Digital print embellishment allows the artist to add in special touches and effects that cannot be created digitally. Perhaps the most noticeable additions to the piece are the multiple layers and colors of metallic paint which were used to add emphasis and to make the piece literally shine!

Metallic paints were applied using both brushes and paint pens for the greatest amount of control. The final painting also features a slightly textured overcoat of Golden Regular Gel (Gloss) medium applied with a large brush.

Painting My Best Friend. © Chris Price

7

Landscapes

Landscapes are among the most popular paintings people enjoy creating and collecting. Artists have developed many inventive ways to capture the essence of a landscape using a variety of media. The beauty in painting landscapes is that anything goes—landscapes have been done in every style and medium. A landscape painting will capture a different personality each time it is painted, whether it is in oils, pastels, chalks, watercolors, pencils, or any of the art materials. Each material will give the same landscape subject a totally different end result. In this chapter, we'll experiment with a number of different styles for painting landscapes so you can get a feel for the many exciting possibilities.

Basic Landscape Painting

Most people come home from vacations with photographs similar to the one we'll use in this lesson. It's got a foreground, subjects, background, depth of field, and a good mix of highlights and shadows. In a few easy steps, your vacation and landscape images can be transformed into an impressionist painting.

Go to FILE>OPEN, choose **basic_landscape_ORIG.jpg**.

First we need to create an under painting to paint.
Go to WINDOW>SHOW UNDERPAINTING
Click the QUICK CLONE button and the TOGGLE TRACING PAPER icon to hide the image.

Choose the brush: CLONERS / IMPRESSIONIST.
SIZE: 56 OPACITY: 100%

In the Auto-Painting palette, there are a number of choices in the STROKE drop down menu.
Choose SWIRLY for the stroke.

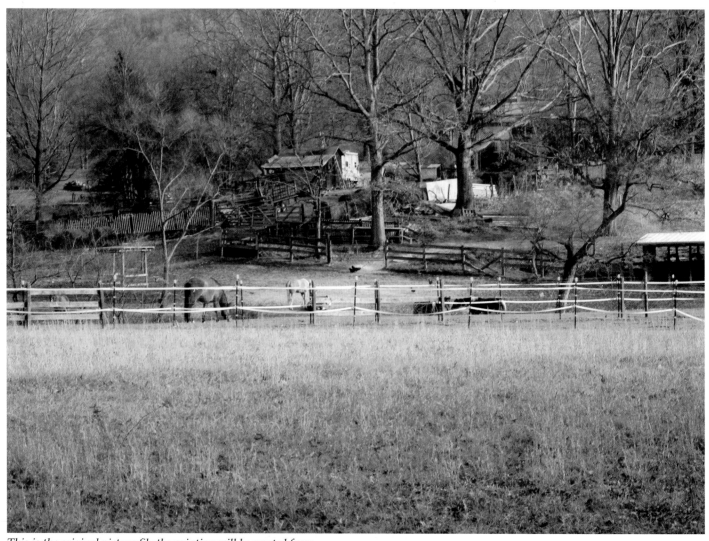

This is the original picture file the painting will be created from.

Pressure Modulate
360 Degree Bearing Rotate
Size/Bearing Modulate
Size/Tilt Modulate
Fade In/Out
Short Stroke
Bearing Rotate
C Curve
Circle
Diagonal
Hatch
Medium Dab
Scribble
Scribble Large
Short Dab
Single Sketch Line 1
Single Sketch Line 2
Sketchy Circle
Sketchy Square
Splat
Square
Squiggle
Sweeping S Curve
✓ Swirly
Triangle
Zig Zag

Swirly

Randomness: 80%
☑ Pressure: 85%
☑ Length: 75%
☑ Rotation: 180°
Brush Size: 75%
Speed: 100%

Press the Stop button when your image looks similar to this.

Do not click SMART STROKE PAINTING. By not clicking that box, SMART SETTINGS will not be able to be activated either.

Press the PLAY button.

Press the STOP button when the image begins to look like an impressionist painting. Painter will not know when to stop automatically because we did not choose the SMART SETTINGS.

Next, we will add more paint to the image with hand brush strokes.

Still using the CLONERS / IMPRESSIONIST brush, change the settings to SIZE: 50 OPACITY: 49% RESAT: 18%.

Click the Rubber Stamp in the colors palette; this will allow you to add color rather than Clone.

Paint parts of the image with colors that add more depth and warmth to the painting. Choose deeper but similar colors to those already there. To add more depth and texture to the grass, use a variety of colors, not just one shade of green.

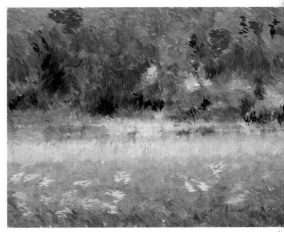

The paint being laid down is not the exact same color as those already in the painting. Richer hues were chosen to give the image depth.

Still using the Impressionist brush, change the SIZE to around 15 to bring out details.

Click the Rubber Stamp to make the brush a Cloner.

Click the TOGGLE TRACING PAPER icon to turn the image back on so the details can be seen. Continue painting the details following the shapes in the image.

Fight your urge for realism and stick with the Impressionism of the painting.

Impressionism is about leaving out detail and tricking the viewer's eye to see more than is there by filling in details with their mind.

Always zoom out and view your painting full frame, especially when painting details close-up. It's easy for your eye to be fooled into painting in too much detail when zoomed in. By zooming out and viewing the entire image, the eye will adjust and fill in the details.

With the brush still set on Cloner, stroke through the paint that was added.

This will blend the added color brushstrokes with the Auto-Painting. Don't cover the entire area. Just go through the added paint with a few strokes "here and there" until they appear to be part of the entire painting.

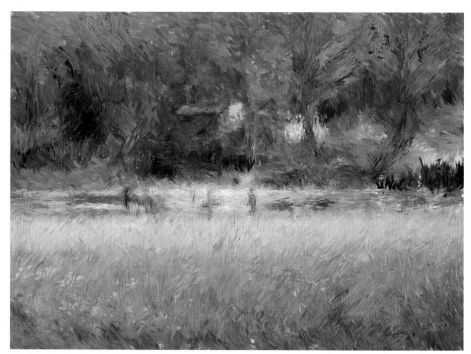

The image has been blended and some details have been brought back—notice the shapes of the horse and the house have appeared.

To work on larger areas of the background with the same brush, the Jitter can be turned up, which will spread the strokes farther apart.

Raising the JITTER to 1.75 on the Impressionist Cloner brush, work on the larger areas of the background.

Zooming out, the painting has a Van Gogh-like feeling, but it needs intensity and richness added to the colors. It's bland and lacking contrast.

The left side shows the Jitter at the default of 1.0, while the right side shows a Jitter of 1.75. Notice how much space appears between the strokes when the Jitter is turned up.

Equalize needs to be applied to the painting to add the intensity it is missing.

Go to EFFECTS>TONAL CONTROL>EQUALIZE.

In the Equalize Palette, modify the Equalize effect slightly by moving the black slider to the left and the white slider to the right. This retains more details in the shadows while toning down the highlights.

To avoid overwriting the original, SAVE AS with the new name **basic_landscape_01.jpg**.

Zooming out again to evaluate, it becomes obvious that the white blank areas are a distraction. By adding more paint strokes we can warm up the painting and fill in the white spots. Use the DROPPER tool to select colors from areas adjacent to where you will be painting. Then, in the Color palette, move the slider inside the SATURATION VALUE TRIANGLE to change the saturation while still staying in the same color family. Paint over any distracting white areas.

Use the BURN TOOL to tone down the corners and on any other areas that seem too bright. This will intensify the colors without changing the brushstrokes.

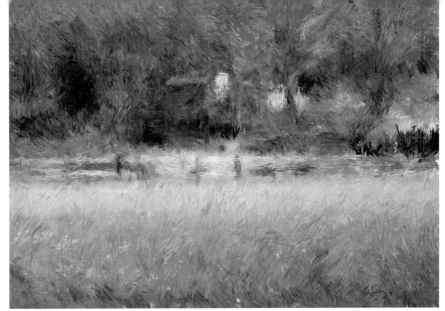

The background has been painted, but the image still lacks contrast.

Move the sliders in the Equalize palette to add intensity to the painting.

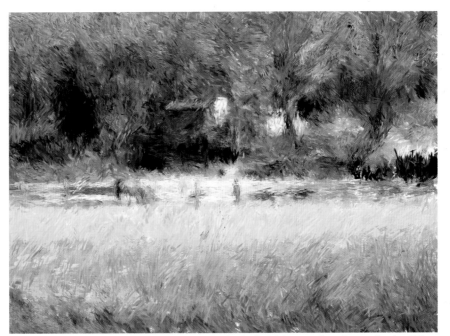

While this painting may appear completed, it's the finishing touches that make the difference—like painting over the white chimney and burning in the corners.

Looking at these two versions side by side, we can see in the image at right that the whites have been muted with a new layer of pink to warm up the painting, and the edges have been burned in.

SAVE AS with the name **basic_FIN.jpg**, and this painting is finished.

High Contrast Landscapes

It's tempting to ignore images such as this one and assume it won't make a great painting. The key is to remember that these images are only for photo reference; the point is to transform them from a photograph to a full-fledged painting. This one in particular is a striking photograph that has many possibilities.

Go to FILE>OPEN, choose **high_contrast_ORIG.jpg**.

This image needs to have some Saturation added to create better colors for a painting.
Go to EFFECTS>TONAL CONTROL>ADJUST COLOR.
The Adjust Color palette appears; raise the Saturation to around 100%.

Open the Auto-Painting palette (WINDOW>UNDERPAINTING).
Click QUICK CLONE.
In the Auto-Painting palette, click both SMART STROKE PAINTING and SMART SETTINGS.

Choose the brush: PENS / LEAKY PEN.
SIZE: 17.6 OPACITY: 100%
RESAT: 100% BLEED: 20%

We'll use this dull picture to create a high contrast landscape painting.

After raising the Saturation, the colors are more intense.

File Edit Canvas Layers Select Shapes Effects Movie Window Help

Size: 17.6 Opacity: 100% Resat: 100% Bleed: 20% Jitter: 3.25

Changing the Bleed affects how much the colors smear. Raise it to at least 20%, but test out different strengths for your own painting style.

Set the brush to Clone by clicking the Rubber Stamp icon.

Click the TOGGLE TRACING PAPER icon so only the white canvas is showing.

Click the PLAY button and let the Auto-Painting finish.

Remember to SAVE AS with the new name **high_contrast_FIN.jpg**.

The image after Auto-Painting with the Leaky Pen brush.

A close-up of the image shows the neat splatter effect of the Leaky Pen brush.

Less is More Landscape

Paintings have less details than a photograph, so a "less is more" approach works well with a landscape photograph as reference that has out of focus edges. This effect can be achieved by using a special piece of equipment attached to your camera called a Lensbabie, in photo software, or it can even be done in Painter.

This photo was done with a Lensbabie, but let's use Painter to make it even more out of focus in the areas that are already softened. This way you'll know how to get this look without the original picture already looking blurred at the edges.

Go to FILE>OPEN, choose **valley_ORIG.org**.

We are going to use the Zoom feature.
Go to EFFECTS>FOCUS>ZOOM BLUR.
The Zoom Blur palette appears. Leave the default settings.

Move the cursor outside of the palette and over the reference picture; you'll see the cursor turn into crosshairs.
Choose and click on a spot right around the red farmhouse in this image. Click OK.

The original photograph we'll use to make softened edges in a painting.

The Zoom Blur palette. Move the palette so you can see the farmhouse in the photo.

The image after the Zoom Blur has been applied.

Move the black slider to the left until it's no longer under the graph.

After the image is "Zoomed," the contrast is flat; we need to pump it up with Equalize and Tonal Controls.

Go to EFFECTS>TONAL CONTROL>EQUALIZE.

At the default settings, Equalize renders the blacks solid, but this image should be a little less black. Move the black slider to the left a bit.

Go to EFFECTS>TONAL CONTROL>ADJUST COLORS.

In the Adjust Colors palette, take the Saturation all the way to the right, to 139%.

The image has been Equalized so the contrast is higher.

Raise the Saturation all the way up in the Adjust Color palette.

SAVE AS with the new file name **valley_01.jpg**.

Now go to FILE>CLONE.

Open the Underpainting Palette (WINDOWS>SHOW UNDER-PAINTING).

In the Underpainting Palette, click SMART STROKE PAINTING and SMART SETTINGS.

After raising the Saturation, we now have bright colors that we can begin a painting with.

Choose the brush: OIL PASTELS / OIL PASTEL.

Size: 17.7 OPACITY: 41%
GRAIN: 17% RESAT: 0%
BLEED: 58% JITTER: 1.02

The settings for the Oil Pastel brush.

Click the Rubber Stamp to make the brush a Cloner.

Now press the PLAY button to start Auto-Painting; let it paint until finished.

Note: It's good to get in the habit of selecting Smart Stroke Painting and Smart Settings before choosing a brush. In Painter X, when both Smart Stroke Painting and Smart Settings are checked, it automatically switches to the Smart Stroke Brush Category and overrides your latest brush selection. If you have made the mistake of selecting the brush before clicking the settings, the fast workaround I use is to open the Tracker palette (Windows>Show Tracker). If you have used the brush recently in the painting, you can choose it again in the Tracker (with the same settings as when you used it earlier) instead of finding the brush in the Category and Variant menus again.

After the Auto-Painting finishes, we are going to paint some of our own brushstrokes still using the Oil Pastel brush as a Cloner.

Lay down brushstrokes following the lines of the landscape that are already there, pulling the brush across the mountaintop to break up the sharp lines.

The copied layer has been added in the Layers palette.

Then follow the diagonal lines that the Zoom Blur effect created to add some softness to them.

Vary the brush size and the Opacity for pleasing effects and vary the pressure on the tablet to have a variety of strokes.

Do not paint in the middle where the focus point of the zoom is; this way, it will stay sharper and more defined and direct the viewer's eye to the composition point.

After finishing the extra strokes, let's take it a step further. We are going to create a new layer and use a new brush on that layer.

The top layer is turned off.

The top layer is turned on so you can see the effect of the brushstrokes.

To create a layer that is an exact duplicate of the original painting, go to:

SELECT>ALL,

EDIT>COPY,

EDIT>PASTE IN PLACE.

This will create a new layer in the Layers palette with the image perfectly centered over the original layer.

Choose the brush: DISTORTION / MARBLING RAKE.

SIZE: 16 STRENGTH: 20%
GRAIN: 100%

The Art of Digital Photo Painting: Using Popular Software to Create Masterpieces

The finished painting is vastly different than the reference picture we started with. However, the tonal range between the painting and the original photo is the same. The highlights and shadows are still in the same places and if you compare the two, you'll see the same colors and values. This is what makes having good photo references important, even if the pictures themselves aren't technically "great."

Paint with the brush over the outside areas again, avoiding the center of interest.

When finished with the brush, click on the EYE icon for the top layer shown in the Layer's palette to turn its visibility off. Turn the visibility on and off to see the effect of the Marbling Rake brush.

Lower the Opacity of the layer to whatever looks good for your image (try around 75%).

DROP the layer by using the LAYER COMMANDS icon on the far left of the Layers palette.

SAVE AS with the new name **valley_FIN.jpg**.

The joy of painting landscapes, seascapes, or cityscapes is that the more experimental the painting, the better it will get. Keep using SAVE AS with new names for all the versions so at any time they can be accessed and reused for new variations.

gallery

Bruce Hamilton Dorn & Maura Dutra

Meet one of the most talented couples, both of whom are published artists and Corel Painter Masters like myself. Bruce's amazing lighting in his photography has won him the title of one of Canon's Explorers of Light. Add to that his exquisite brushwork and painting abilities with Painter and you have a mix that is hard to beat.

In Maura's flower photography, light and paint literally jump off the page at you, and are so three dimensional you want to touch them.

Cold Crossing. © Bruce Hamilton Dorn

Cold Crossing
Bruce Hamilton Dorn

"*This personal painting was cloned from an original photograph created at the iDC Photography "Shootin' and Paintin" workshop in beautiful Jackson Hole, Wyoming. Brushes: personal variations of the Sargent, Smeary Round, Dry Ink, and Soft Cloner. The finished painting was carefully-layered with the "Brightly Mottled" and "Bleached Blues" texture effects from "Mama Maura's texture for Painter" v01. The final image was printed on canvas with our Canon iPF 5000 wide-format printer.*"

Flamenco Swirl
Bruce Hamilton Dorn

"*This commission was created for the dancer's self-promotion campaign and is one of several of my dance images featured in the advertising campaign for Canon cameras. Brushes: personal variations of the Sargent, Smeary Round, Dry Ink, and Soft Cloner.*"

Flamenco Swirl. © Bruce Hamilton Dorn

Tiffany. © Maura Dutra

This image was finished with a single reduced layer of the "Artifact-Color" texture from "Mama Maura's Textures for Painter" v01. The finished piece was printed on canvas with our wonderful Canon iPF 5000 wide-format printer. **"**

Tiffany
Maura Dutra

" This is a cloned painting of an original photograph. The background pattern was designed to work with the patterns on the clothing. Using a Cloner Brush, the "Rusty Edges" effect was

applied from the texture choices available in "Mama Maura's Textures for Painter" v01. The final image was printed on Photo Rag Fine Art Paper with our archival Canon iPF 5000. **"**

Yellow Roses in Teapot
Maura Dutra

" This cloned painting of an original photograph was composed in-camera for this still life project. The aging effect was achieved using a Cloner Brush to apply a combination of "Subtle Craquelure" and "Artifact Color" effects from the texture choices in Maura's texture collection. **"**

Yellow Rose. © Maura Dutra

Painting
Flowers

There really is an infinite variety of options when it comes to painting flowers, and it's hard to choose a bad one. With so much color and texture, flowers lend themselves to being painted, and regardless of the style, they are almost always beautiful. For digital artists, flowers are always a favorite because of the many techniques that can be applied and practiced on a single image. Flowers are like landscapes in that they are very popular as home décor paintings. Using underpainting techniques combined with hands-on brushstrokes, Painter makes it easy to create many flower paintings that are an easy and beautiful way to decorate your home.

Painting Flowers with Multiple Programs

Lets explore one flower image done many different ways with a variety of software. We'll be using ArtStudioPro and Snap Art, so if you haven't already installed these programs, do so now (see page 13 for more on software).

Creating Flowers in Twisting Pixels ArtStudioPro

Start by opening Twisting Pixels ArtStudioPro:

Go to FILE>OPEN the **purple_flowers_ORIG.jpg** in ArtStudioPro. Choose the ADVANCED tab at the top of the screen.

Go to FILTER>ARTSTUDIOPRO VOLUME 2>FINGER PAINT.

When rendering is complete, SAVE AS **purple_flowers_fingerpaint.jpg**. The resulting finger painting is interesting, but lacking in details. We'll try using another filter in combination with the finger painting to see if we can get a better result.

We'll use this photo of purple flowers to experiment with different software programs.

This is the workspace for ArtStudioPro; choose Finger Paint from the Filter menu.

The image is a bit dull, but we're about to make things more interesting.

Using the **purple_flowers_finger-paint.jpg** image, go to FILTER>ART STUDIO PRO CLASSICO>DAVINCI; let it render.

Applying new filters creates new layers in the image. The layers of the different paintings show in the Layers palette on the right side of the workspace.

SAVE AS **purple_flowers_01.jpg** and close the image. Open the file in Painter.

The image needs more contrast and details, so we're going to apply Equalize and Sharpening.

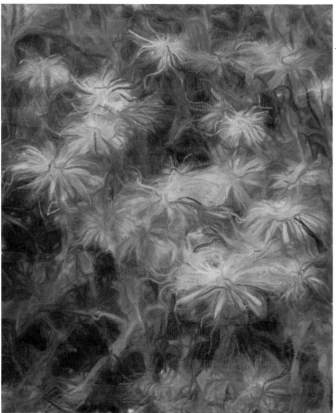

Here is the flower image after the Davinci filter has been applied.

Go to EFFECTS>TONAL CONTROL>EQUALIZE, accept the default settings and press OK.

Now sharpen the image for better details. Go to EFFECTS>TONAL CONTROL>SHARPEN, use the default settings; press OK.

The image now has the punch and details we are looking for.

SAVE AS: **purple_flowers_01_FIN.jpg**.

This is just one finished version of painting the flowers. Now we're going to paint the flowers in a totally different way using the Finger Painting image we saved earlier.

Return to ArtStudioPro and open **purple_flowers_ORIG.jpg**.

Go to FILTER>ARTSTUDIO-PRO>CHARCOAL> CHARCOAL DETAILS.

Let the filter render the results and SAVE AS with the new file name **purple_flowers_charcoal.jpg**.

Open the image in Painter.

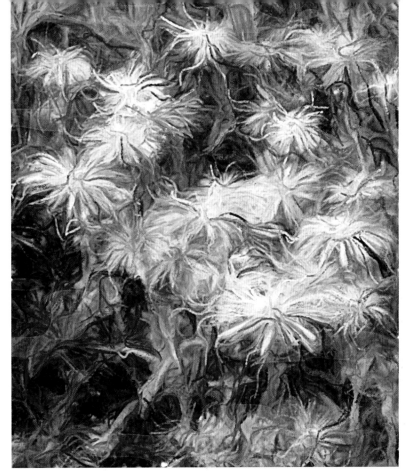

This is the image after Equalize and Sharpen have been applied.

This is the flower image showing the Charcoal Details effect.

Both the Charcoal image and the Finger Paint images should now be open in Painter.

Bring **purple_flowers_charcoal_01.jpg** to the front.

Go to SELECT>ALL, then EDIT>COPY.

Bring forward the Finger Paint version so it's the active painting. Go to EDIT>PASTE IN PLACE.

Now it can be seen that both paintings are in the Layers palette.

In the Layers Palette is a drop down menu called COMPOSITE METHOD; this offers choices for how the two layers are blended together.

Here is the Charcoal painting showing the Equalize and Sharpen effects applied in Painter.

The Art of Digital Photo Painting: Using Popular Software to Create Masterpieces

Apply both EQUALIZE and SHARPEN with the default settings. The painting will become sharper and have better contrast and details.

SAVE AS with the new name **purple_flowers_charcoal_01.jpg**.

FILE>OPEN **purple_flowers_fingerpaint.jpg**

Both images should appear on the screen so you can combine them.

Once the Finger Paint version has been pasted in, both paintings can be seen in the Layers palette.

Before saving the final painting, flatten the image using the Drop command.

SAVE AS with the new name **purple_flowers_charcoal_FIN.jpg**.

You should now have two totally different looking paintings, both created using two programs and selecting different options in each. Obviously, there are many more paintings that can be created by making different creative choices in each program.

Choose the Overlay Composite Method in the Layers palette.

Try them all to see the differences if you feel like experimenting. For this painting, choose OVERLAY and then use the OPACITY slider to lower the intensity of the blending to around 80%.

Finally, in the Layers palette, go to the LAYER COMMANDS icon and choose DROP from the available options.

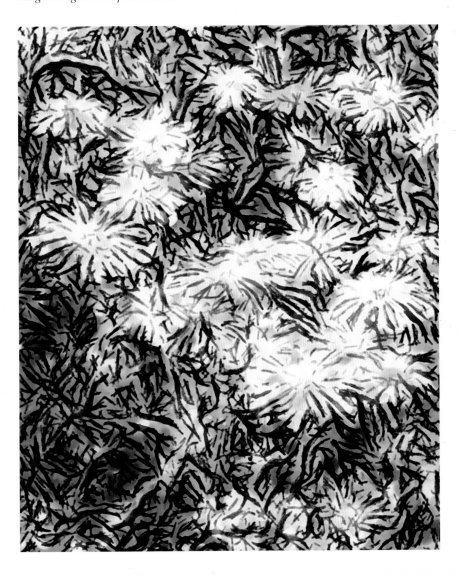

Creating Flowers in Alien Skin Snap Art

Combining Snap Art with Painter X is always a quick and easy method for creating paintings, and the Watercolor effect in Snap Art is especially beautiful for flowers.

Go to FILE>OPEN **pink_flowers_ORIG.jpg**

On a PC, go to EFFECTS>SNAP ART. (If on a Mac, access SNAP ART as a plugin in your graphics program.)
From SNAP ART, choose WATERCOLOR from the drop down menu.

At the top of the screen, choose VERTICAL LEFT in the drop down menu of PREVIEW SPLIT.
The Snap Art interface will now show two windows, the original image and the watercolor image.

Click OK; this opens the image in the Painter workspace.
Now SAVE AS **pink_flowers_01.jpg**.

You will need to open the **pink_flowers_ORIG.jpg** image again in Painter X.

Return to EFFECTS>SNAP ART and this time choose STYLIZE.

Click OK and save with the new name **pink_flowers_02.jpg**.

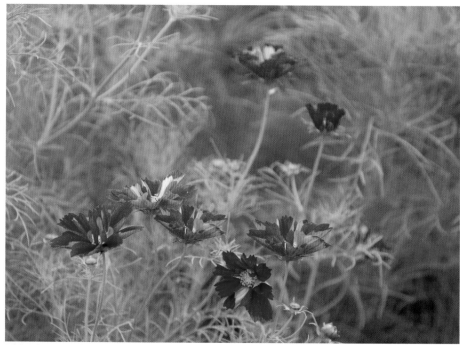

This picture will be transformed using Painter and Snap Art.

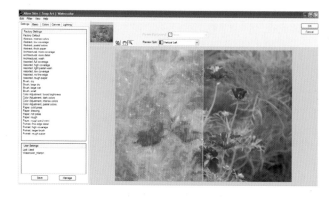

This is the Snap Art interface after Watercolor has been selected.

Here is the saved Watercolor version.

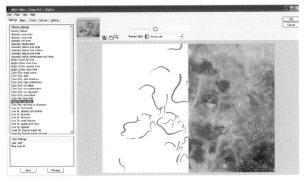

The split window shows the image after Stylize has been selected.

This is the whole image of the pink flowers showing the Stylize effect.

This is what the flower image looks like after using the Negative effect.

Now there should be three images open in Painter X, **pink_flowers_ORIG.jpg**, **pink_flowers_01.jpg**, and **pink_flowers_02.jpg**.

Bring **pink_flowers_02.jpg** to the front. It needs to be prepared to be blended with the final painting.

We will switch the color space to make the background black and the lines turn green.

Go to EFFECTS>TONAL CONTROL>NEGATIVE.

The background should now be black and the lines green.

SAVE AS with the name
pink_flowers_neg_02.jpg.

Next we will layer the Watercolor
version with the original image.
Bring forward
pink_flowers_01.jpg to work with.

Go to SELECT>ALL, then go to
EDIT>COPY.

Bring forward the
pink_flowers_ORIG.jpg image.
Choose EDIT>PASTE IN PLACE.

Lower the Opacity on the new top
layer until details from the bottom
layer begin to show through. Try
around 75% for the Opacity.

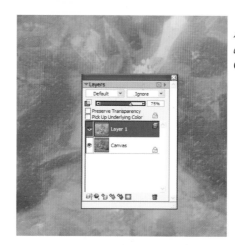

*After combining the two images and
dropping the Opacity, detail from the
Canvas layer now shows through.*

In this image, there is no detail showing in the flower before we combine the images.

*After the Opacity is lowered, notice the detail now showing in the middle of the flower
and how the edges of the flowers are more defined.*

Follow the same Copy and Paste
steps described previously and
copy the **pink_flowers_neg_02.jpg**
version and paste it on top of the
other two layers. There are now
three layers in the layers palette.

This time, change the COMPOSITE
METHOD to MAGIC COMBINE
and watch the black disappear and
only leave the green lines.

There are now three layers in the image, with the negative image showing on top.

Lower the Opacity until the lines melt into the painting.

Flatten the image layers by going to LAYERS>DROP ALL.
SAVE AS **pink_flowers_FIN.jpg**

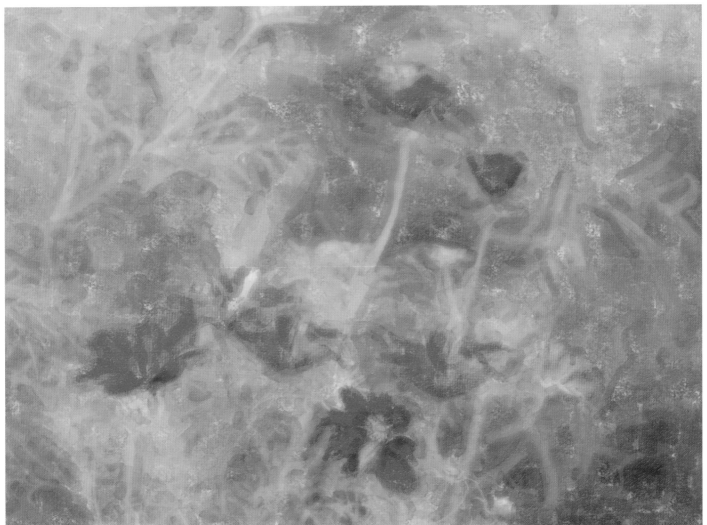

The final flower painting combines techniques from both programs, which creates a painting with interesting brushstrokes.

This same painting can now be changed into a Pop Art version by using EQUALIZE at the default settings.

SAVE AS:
pink_flowers_popart_FIN.jpg

Flower Painting in Limited Colors

The home decorating market loves big, bold images with limited colors. Limiting the colors allows the paintings to be displayed in a variety of decorating color schemes. A predominantly yellow painting will look wonderful in almost any color scheme. But adding reds and blues to it will limit where it fits into a decorating plan.

In this lesson we'll work with a bold but very plain image that has a very limited color palette. By limiting the use of colors to four or less, the painting can become the centerpiece to a room, livening up a dark color palette or being the focus of a bright room.
Go to FILE>OPEN **yellow_flowers_01_ORIG**.

QUICK CLONE the image.

Toggle the image off with the TOGGLE TRACING PAPER icon.
Use the Auto-Painting palette with both SMART STROKE PAINTING and SMART SETTINGS clicked.

Choose the Brush: ARTIST OILS / CLUMPY BRUSH.
Set the brush as a Cloner by pressing the Rubber Stamp in the Colors palette.

Press PLAY and watch the painting until it's done.

After Auto-Painting with the Clumpy Brush, the painting has an impressionistic quality.

The colors look a little flat, so we'll use Equalize. Go to EFFECTS>TONAL CONTROL>EQUALIZE. Use the default settings and press OK.

SAVE AS **yellow flowers_01.jpg**.

Add a layer to paint on by clicking the NEW LAYER icon.

Next we'll open the color mixer; go to WINDOW>COLOR PALETTES>SHOW MIXER.

Choose a limited number of colors that are already found in the painting (about 4). Use the DROPPER tool to select a color; after choosing it, paint it onto the MIXER canvas. Repeat this for the other colors you have decided to use. This will ensure the same colors are used over and over again. It will also make it easier to keep choosing the same colors quickly from the Mixer while painting.

To paint with the colors in the Mixer Palette, the DROPPER in the Mixer palette is used. Do not use the Dropper from the Toolbox.

Use the brush: ARTIST OILS / CLUMPY BRUSH.
SIZE: 10 OPACITY: 100%
GRAIN: 85%

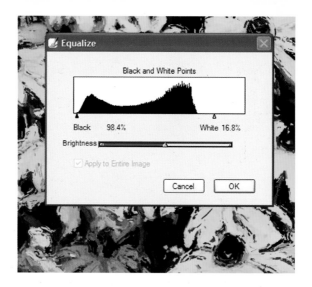

The painting has been brightened with Equalize.

These colors were selected from the painting and brushed onto the Mixer palette.

130

The paint that was applied with the Clumpy brush should now appear broken up.

If you turn off the visibility for the bottom layer, you can clearly see the types of brushstrokes being made.

Set the brush for painting by clicking the Rubber Stamp icon.

Paint along the flower's shapes in a variety of brush sizes using the colors from the Mixer palette.

To see the colors and how they are painting, turn OFF visibility for the bottom layer of the painting by clicking on the EYE icon next to it. All that will show now is the new brushstrokes of the paint added on the top layer.

After the shapes of the flowers look evenly painted, we'll blend the new paint in a little to soften the strokes.

This is the final yellow flower painting before taking it a step further.

Choose the brush: BLENDERS / WATER RAKE.

SIZE: 10 OPACITY: 10%

GRAIN: 26%

Once done painting, adjust the Opacity to your liking.

DROP the layer using the LAYER COMMANDS drop down menu.

SAVE AS with the new name **yellow flowers_02.jpg.**

Taking it a Step Further

Now we'll create new versions from this one image to have a variety of different paintings.

Each variation starts by opening the same file: **yellow flowers_02.jpg**.

Since these short variations show a variety of techniques, there's no need to save every image unless you find a style you really like and want to revisit later.

This is the Adjust Dye Concentration palette.

Dye Concentration

Go to EFFECTS>SURFACE CONTROL>DYE CONCENTRATION.

Set the USING drop down menu to UNIFORM COLOR.

Set the MAXIMUM to 160%; set the MINIMUM to 70%.

Click OK.

The color of the entire image has been changed by using the Dye Concentration palette.

Posterize

Go to EFFECTS>TONAL CON-TROL>POSTERIZE.

Change the number to 4 in the Posterize window.

This will reduce the number of color levels in the image.

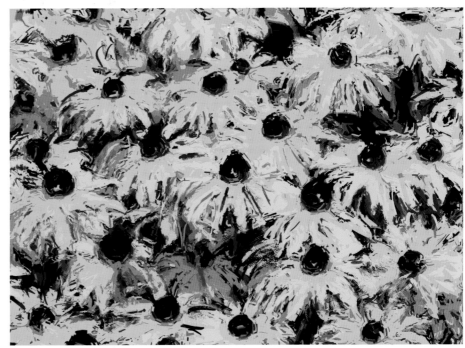

This painting shows the effect of limiting the posterization to only four colors.

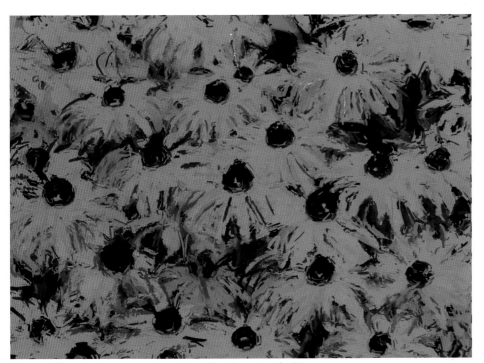

A very different color was easily achieved by changing the Hue.

Hue

Go to EFFECTS>TONAL CON-TROL>ADJUST COLORS.

The Adjust Color palette appears.

The USING dropdown menu should be set to UNIFORM COLOR.

Use the HUE SHIFT slider; to create a vivid pink color, move the slider left.

Quick Warp

Go to EFFECTS>SURFACE CON-TROL>QUICK WARP. In the Quick Warp palette, set the POWER to 2.0 and the ANGLE FACTOR to 2.0.

Click the SPHERE button.
This will let you distort an image as if it were a flexible surface, allowing you to get effects that look like mirror distortions.

Woodcut

Go to EFFECTS>SURFACE CON-TROL>WOODCUT. In the Woodcut palette, change the settings to your liking or use the image as a guide.

The Woodcut effect makes your image appear as if it was made from a woodcut block.

Take a moment now and go back to the beginning of this series and look at the very ordinary and basic photo reference it all started with and review how many different paintings can be created. This should spark your creativity to find more ways to change the paintings before finishing them.

Trying out all the controls in Painter is part of the learning experience. The more you play the more you learn and explore what is possible and what the different settings will do. When you find something you like and want to come back to, always be sure to save the file and name it sensibly so you can easily refer to the settings used to create it.

Another idea is to also use other software as part of the finishing process. Taking the Woodcut version into Snap Art offers a whole new set of paintings! Once a painting is done, it's never really finished. Sometimes, the step you think is the final one is just the beginning of the real painting. Exploring all the options is part of the creative process.

The Quick Warp palette.

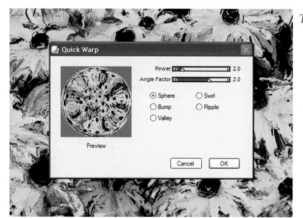

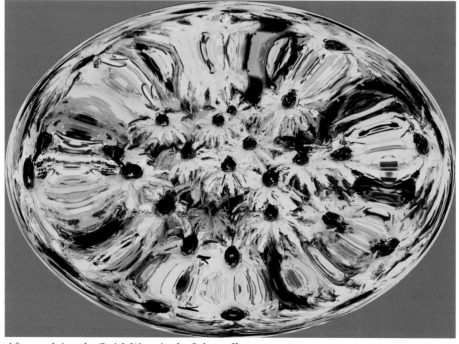

After applying the Quick Warp in the Sphere effect.

The Art of Digital Photo Painting: Using Popular Software to Create Masterpieces

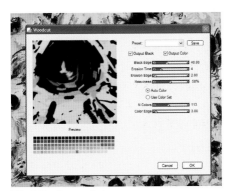

The Woodcut palette.

The woodcut image makes the painting look remarkably different.

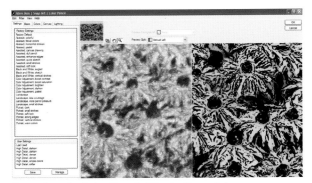

Try using the Color Pencil filter in Snap Art.

The Snap Art Color Pencil filter has been applied to the woodcut painting.

gallery

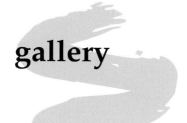

Karen Bonaker

www.digitalartacademy.com
www.paintertalk.net

Karen Bonaker is not only an artist but also an educator. Her extensive tutorials can be found online on many forums. She is also published in the *Imagine Corel Painter* magazine.

Karen has a full spectrum Digital Arts school online at the Digital Art Academy, which is Corel Training approved. (www.digitalartacademy.com)

It is my pleasure to be one of Karen's online instructors and twice a year I host special classes there to teach new techniques. Her lineup of instructors is very impressive and a good follow-up to learning more about Digital Art.

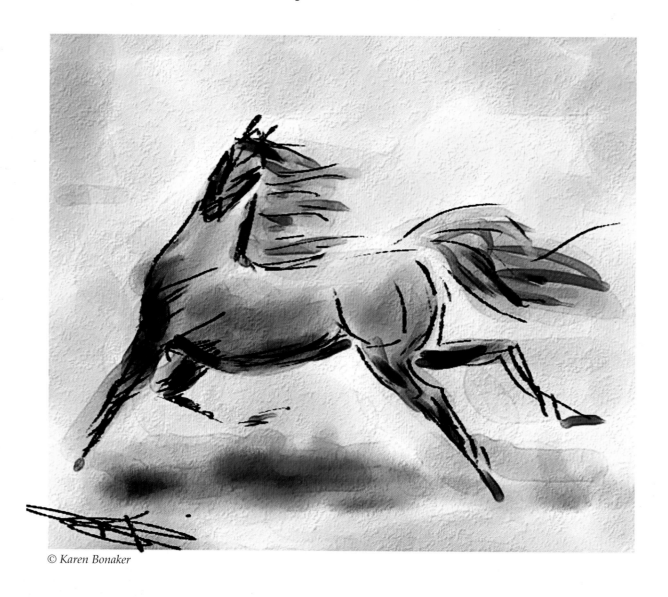

© Karen Bonaker

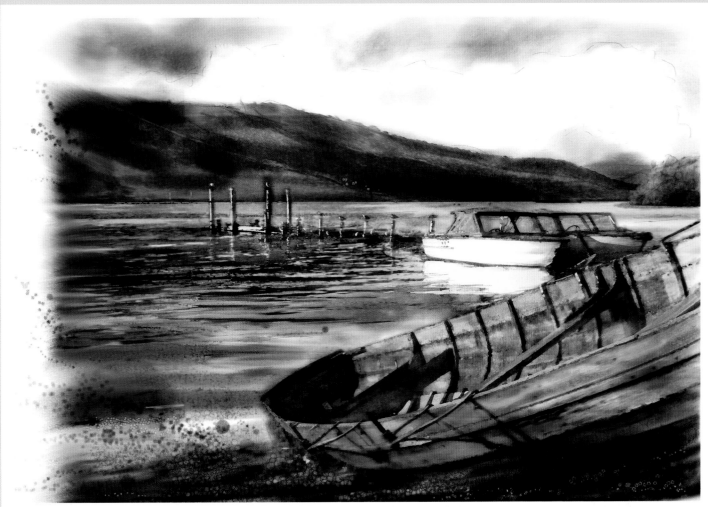

© Karen Bonaker

" Emulating the rich natural media experience via the Digital World is what I try to achieve in my paintings. I consider my work impressionistic with an emphasis on color, texture, and design.

Before I began to paint digitally, I studied watercolor, oils and, mixed media painting at my local college in Aptos, California for many years. I now apply those wonderful effects and techniques to the digital canvas.

I began to paint at a very young age and enjoyed sketching and painting animals, trying to find the unique personality in my subjects. I discovered the software program Painter nine years ago and have, since then, enjoyed creating images using a Wacom tablet and stylus. The same principles can be applied to painting digitally as in traditional media painting. The technique of "painting with digital light" enables me to express skills that are both traditional and state-of-the-art."

9

Texturing, Presentation & Printing

By now, you may be starting to realize that a painting is never really finished. There is always something else that can be done to create new and different versions. Still, at some point you have to decide that a painting is done—at least for the moment. Otherwise, you'll never move on to other works! The last step in digital painting is experimenting with final effects for texture and presentation. It takes a certain amount of inspiration and experimentation to decide what will finally work for a painting. We'll start with an impressionist painting of buffalos and experiment with a number of techniques for finishing a piece of digital painting art.

To do the lessons in this chapter, you'll first need to create the painting of the buffalos, which will be good practice for Auto-Painting. Use the image buffalo_ORIG.jpg to make the painting.

The picture of the buffalos was Auto-Painted with the impressionist Color Scheme using the ARTIST OILS / SARGENT brush with brush settings modified to: SIZE: 32 STRENGTH: 10 GRAIN: 59 JITTER: 0. It was painted twice with exactly the same method. First the photo was Auto-Painted; then, that painting was saved and CLONED and Auto-Painted a second time using the first painting as the clone source.

When finished, save the file as buffalo_01.jpg. We'll be using it frequently in the rest of this chapter.

Presentation

Edging the Painting

The first method we'll learn is how to put a painted edge around the entire painting. The outside edge of the canvas will always be a straight line; any brushstrokes will be applied to the inside edge of the painting.

Choose a Brush. This can be any brush; experimenting is key to finding brushes for the edges of your paintings.

In this example, we'll use: OIL PASTELS / OIL PASTEL 30. SIZE: 30 OPACITY: 100%

Choose a color. In this painting, we really want to have the edges stand out, so we'll choose black.

The Art of Digital Photo Painting: Using Popular Software to Create Masterpieces

All	Ctrl+A
None	Ctrl+D
Invert	Ctrl+Shift+I
Reselect	Ctrl+Shift+D
Float	
Stroke Selection	
Feather...	
Modify	▶
Auto Select...	
Color Select...	
Convert To Shape	
Transform Selection	
Hide Marquee	Ctrl+Shift+H
Load Selection...	Ctrl+Shift+G
Save Selection...	

Go to SELECT>ALL.

Then return to the SELECT menu and choose STROKE SELECTION.

Almost as if by magic, the stroke is put around the painting with the brush and colors we selected. To undo the marching ants that designate the selection, go to SELECT>NONE.

Try other brushes with this method. Here are a few examples and their settings. If you're going to try them, open the **buffalo_01.jpg** file for each one.

A black stroke has been applied around the painting.

ERASERS / TAPERED BLEACH 30
SIZE: 90 OPACITY: 50%

DISTORTION / HURRICANE
SIZE: 70 STRENGTH: 100%

ARTISTS / IMPRESSIONIST
SIZE: 56 OPACITY: 100%

Using an Eraser brush added a faded edge to the painting.

Distortion brushes won't change the colors, but they will add effects to the edge. The Hurricane brush creates the curly look seen here.

Here, I used the Impressionist brush stroke around the edge. Black was used for emphasis, but any color can be used.

Create a rectangular selection on that layer and use STROKE SELECTION. This stroke is now totally movable with the LAYER ADJUSTER tool and can also be reshaped and resized with EFFECTS>ORIENTATION>FREE TRANSFORM.

Remember to DROP the layer and save it with a new name when finished.

Make a Rectangular selection inside the painting.

Edge effects can also be applied to a selection anywhere in the painting. Open the **Buffalo_01.jpg file**.

Use the RECTANGULAR SELECTION tool, and make a selection anywhere inside the painting.

Select the same ARTISTS / IMPRESSIONIST brush from the last example, if it's not already in your brush palette.

Go to the SELECT>STROKE SELECTION.

Now the edge effect is inside the painting. Another extension of this method is to put the SELECTION on a layer by adding a layer in the layers palette.
ADD a layer.

This image shows both edge effects that we just applied. The first was a selection on the canvas while the second was made on a new layer, then resized and moved using the Free Transform tool.

Changing the Canvas Size

Adding extra canvas around the painting is a great way to add more visual space, and also make room for more effects to be used. We are able to use brushes, add colors, and paint edges onto the canvas to give it a more polished appearance.

Open the image **buffalo_01.jpg**.

Go to SELECT>ALL.
Then go to CANVAS>CANVAS SIZE.

In the Canvas Size dialog box, enter the number of pixels for how large the border should be. 250 pixels equals one inch. If the numbers entered are all the same, the canvas space created around the painting will be equal.

After adding the extra canvas, it might not appear on the screen. If this happens, choose the MAG-NIFIER tool and then choose the FIT ON SCREEN button at the top of the workspace. The entire image should now show up with the canvas around it showing.

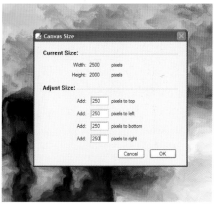

This is the Canvas Size dialogue box. 250 pixels have been added on all sides.

NOTE: Now that the size of the painting has been changed, none of the original clone sources can be used to do any additional painting from, as they are not the right size. That is a good reason to not change the canvas size until you are absolutely sure that none of the clone sources will be needed for additional painting.

The new canvas has been applied to the image.

Now let's fill the empty white space with a color gradient.

With the RECTANGULAR SELECTION tool, make a selection around the image only.

Now go to SELECT>INVERT.
The selection should now be on the outside of the painting.

Select the PAINT BUCKET tool.
At the top of the screen, click the FILL drop down menu and choose GRADIENT.

To choose a GRADIENT, go to the GRADIENT palette in the Toolbox (it's the top right square just below the Color Selector boxes).

The Gradient box.

Click the GRADIENT box and the drop down menu appears; choose the TROPICAL FRUIT gradient. Once selected, the menu will close.

Click on the GRADIENT palette again; click the small arrow at the top right of the menu and select LAUNCH PALETTE from the drop down menu.

Launch the Gradient Palette in the drop down menu.

Choices can now be made as to how the gradient is applied. Choose the SPIRAL GRADIENT effect.

Click the PAINT BUCKET tool on the selected area to fill it with the gradient pattern.

Go to SELECT>NONE to turn off the selection.

Once finished with the fill for the Gradient, SAVE AS:

buffalo_gradient.jpg.

The Tropical Fruit Gradient has been selected with the Spiral Gradient effect.

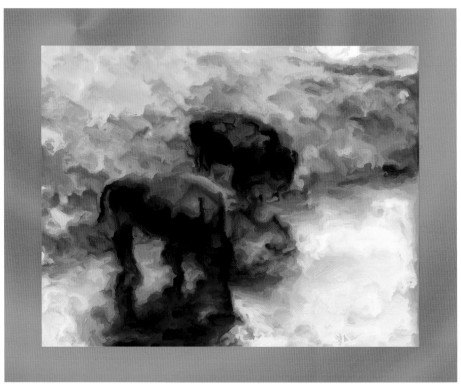

The Gradient has been applied to the selection.

Softening the Edge

The edge between the painting and the color canvas can be softened or changed using brushes. Here are a few examples of brushes and how they affect the edge. To try these methods, open the **buffalo_gradient.jpg** file and Clone it each time. As you try each option, apply brushstrokes around the entire edge of the painting and blend them outwards into the Gradient-filled background.

FX / CONFUSION
SIZE: 34 STRENGTH: 50%
GRAIN: 20%

FX / SQUEEGEE
SIZE: 18 STRENGTH: 33%

BLENDERS / ROUND BLENDER 10
SIZE: 30 OPACITY: 50% RESAT: 0%

BLENDERS / WATER RAKE
SIZE: 28 OPACITY: 26%
GRAIN: 26%

The FX / Confusion brush.

The FX / Squeegee brush.

The Blenders / Round Blender brush.

The Blenders / Water Rake brush.

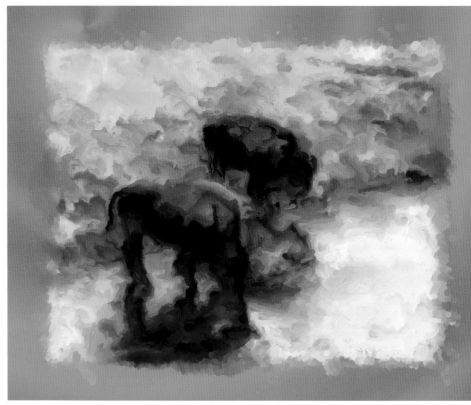

The WATER RAKE brush responds differently to both pressure and direction. Use this brush with both horizontal and vertical strokes and vary the pressure on the tablet with the stylus and see the wonderful, splashy results. In particular, this brush looks very much like real paint has splattered onto the outside of the painting on the border.

This final version uses the Gradient and the Water Rake brush for making an interesting edge effect.

To sign the paintings, simply use one of the CALLIGRAPHY brushes and sign your personal signature wherever you want. There are no hard and fast rules about this in the art world. While most people are accustomed to seeing the signature in the lower right, it's acceptable to sign art in your own personal style.

Always save your art with one version unsigned. You never know when you may want to enter a contest or juried art show that won't accept signed entries. This is common, especially for Internet groups that have challenges and other fun contests where the signature would give away who the entry is from. Another option is to not sign your artwork digitally, but to wait until it's printed and sign the actual print.

The CALLIGRAPHY / SMOOTH PEN 10 is a good brush to sign your work with.

Textures

Taking the digital file to print requires many decisions about textures. If everything that you create is going to stay in the computer and never be printed, there are some textures that look wonderful as long as they stay on the screen.

In the real, hands-on world, it has to be taken into consideration that whatever the digital file is printed on will have its own texture and identity. So adding texture to the digital file needs to be more cautious so it doesn't take away from the original media texture or clash with it by turning the art into something difficult to view. We will explore the digital and printing techniques to learn what works best for each media.

Adding Texture with Brushes

One of the easiest ways to add texture is to simply paint it exactly where you want it. There are brushes that will do this, but it's important to be able to control where the texture is applied and how much texture is used.

This can be achieved by either Cloning the painting or by adding a layer. Not all brushes will work on an empty layer. Other times, they will work, but you can't lower the Opacity on the layer. So follow the tips here; after trying out these methods, explore more of the texture brushes.

Go to FILE>OPEN **buffalo_01.jpg**. CLONE the image.

We need to see the painting in Actual Pixels size. This will show the texture as it will look when printed at the document's actual size.

Choose the MAGNIFIER tool; at the top of the workspace, choose ACTUAL PIXELS.

Use the GRABBER tool to move the painting to an area that has a good mix of light and dark colors to see how the texture is going to affect them both.

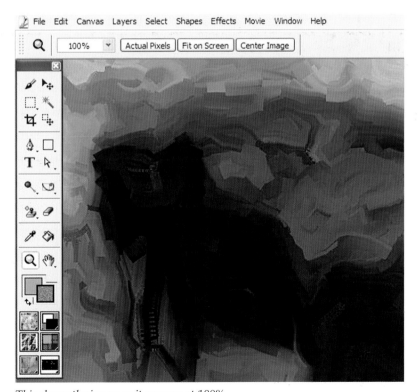

This shows the image as it appears at 100%.

Using Impasto Brushes

The Impasto Brush Variants are tricky, but valuable once you get the hang of them. Once brushed onto the painting, they leave a texture that is permanent that soft cloning from the original Clone source will not affect. There are two ways to control the Impasto texture.

The first is to use the Toggle Impasto Effect icon, which looks like a puffy star and can be found in the same column as the Toggle Tracing Paper icon. Once clicked, any Impasto effect will be gone, but no other Impasto brushes can be used on the painting or all the previous Impasto brushstrokes will pop back up.

The second way to work with this problem is to Toggle the Impasto Effect Off, and then SAVE AS with a new name. Close the file, reopen it, and once again Impasto brushes can be used without the previous brushstrokes showing up. Also, if Impasto brushes have been applied to the canvas and more control is desired to Soft Clone back part of the painting, SAVE AS with a new name and then reopen and the Impasto brushwork will be there. However, now the Soft Cloner brush can be used to Clone the original painting from the Clone source.

This is the Toggle Impasto Effect icon.

When painting texture, follow the lines of the painting and vary the size of the brush to match the size of the area being painted.

The entire painting does not need to be covered with the brush. Only paint where texture is desired.

The Impasto brush was used to add texture. Note that it was not used everywhere, just in a couple of places to mimic real brushstrokes.

1. IMPASTO / CLEAR VARNISH
SIZE: 19 OPACITY: 63% RESAT: 0

2. IMPASTO / DEPTH LOFTER
SIZE: 12 OPACITY: 100%

The Depth Lofter is extremely sensitive to the amount of pressure the stylus puts on the tablet. Using it while pressing harder will give a larger and rounder lift to the brushstrokes, emulating very thick paint. Using short, light strokes will give more controlled, straighter lifts to the painting.

The Depth Lofter brush lays down very textured paint. The harder you press with the stylus, the larger the texture becomes.

The pressure put on the tablet with the stylus will increase the grain depth with the grain Emboss brush.

3. IMPASTO/GRAIN EMBOSS
SIZE: 37 OPACITY: 11%

4. IMPASTO/SMEARY VARNISH
SIZE: 14 OPACITY: 63%

These are just a few of the Impasto Category brushes that will add texture to your painting. All of them are very different and their effects react just like real wet impasto paint on canvas.

Smeary Varnish has the effect of mixing varnish with the paint on the canvas.

Adding Textures with Effects

Using options from the Effects menu, we can apply surface texture to the whole image. In this example, we'll give depth to the brushstrokes so they look like they were done with oil paints.

OPEN **buffalo_01.jpg.**

Go to EFFECTS>SURFACE CONTROL>APPLY SURFACE TEXTURE. The Apply Surface Texture palette pops up.

Change the USING drop down menu to IMAGE LUMINANCE. Then apply the rest of the settings from the image of the palette seen to the right. When the settings are entered, click OK.

Find the Apply Surface Texture option under the Effects menu.

Enter these settings in the Apply Surface Texture palette.

Looking at this image at 100% size, the texture can be seen, but it doesn't really give a good idea of what it will look like when it's printed.

By zooming in, it's easier to see how the texture will look when the image is printed.

Adding Texture with Paper

After the painting is finished, we can apply a texture to digitally replicate the look and feel of different art papers.

OPEN the **buffalo_01.jpg** image. Add a new layer to the painting. The new layer needs to be filled with 50% Gray.

To change the color specifically to 50% Gray, go to WINDOW>COLOR PALETTES>SHOW COLOR INFO.

Change all of the RGB numbers to 128, which makes the 50% gray.

Select the PAINT BUCKET tool and click on the empty layer to apply the gray color. The screen will appear to be solid gray. Change the COMPOSITE METHOD to Overlay and the image is again revealed.

Launch the PAPERS palette by going to WINDOW>LIBRARY PALETTES>SHOW PAPERS.

Using the drop down menu in the top right of the palette, choose a paper texture. For this example, I selected RETRO FABRIC.

Now we're going to make changes to the paper texture. Go to EFFECTS>SURFACE CONTROL>APPLY SURFACE TEXTURE. The Apply Surface Texture palette appears.

Set the USING drop down menu for PAPER and apply the settings from the image of the Apply Surface Texture palette seen to the right.

Click OK to apply the effect.

Choose the Retro Fabric texture from the drop down menu in the Papers palette.

Change the RGB settings to make the layer gray.

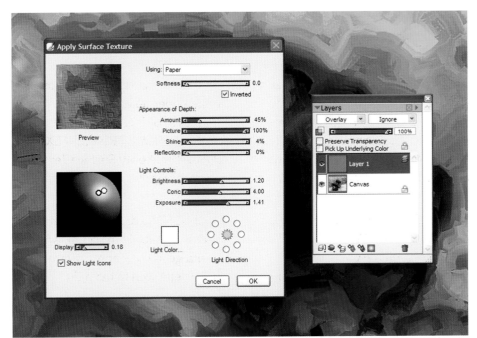

Use these settings in the Apply Surface Texture palette.

Here is a close-up of the Retro Fabric paper texture.

The Opacity of the layer can be adjusted now with the slider.

Then DROP the layer and SAVE AS with the new name: **buffalo_retropaper.jpg**.

Don't forget to zoom in and view at ACTUAL PIXELS.

Always save your paintings with and without texture. Adding textures with papers is a wonderful method to show off paintings on the Internet. Be very careful when adding paper textures to finished

Note that the texture now shows in Layer 1, and the Opacity has been lowered.

paintings that will be printed on canvas or paper media. If this RETRO FABRIC texture is added to the painting digitally and then printed on canvas, it is possible that the painting will deteriorate and lose its shapes and sharpness because the two methods will clash. Test the prints and choose the best combinations of textures with the media it is printed on.

The best rule is to always experiment and save the original, untextured files of the paintings. This way you can change the painting later after seeing a test print if it has less than desirable results.

Printing

Once your paintings are done, there are many exciting decisions to be made as to how they will be printed. Options include countless varieties of paper, canvas, gift items, jewelry, accessories, tiles, and much more. New products are constantly being developed on which artists can print their work. An important first decision is whether to print in-house on your own printer or with a lab.

In-House Printing

Small home printers have become very affordable, they are easy to operate, and they produce beautiful color. Printing your work at home is now easier and less expensive than ever before, and the quality keeps improving.

Inkjet printers are what you want for printing your paintings and pictures. These printers use a nozzle that sprays droplets of ink onto the paper, producing high-quality prints and graphics. These printers use small liquid ink cartridges that can be replaced as they empty. Don't be tempted to use the "refillable" ink cartridges, and always use the brand of ink recommended by the printer manufacturer. Anything else will result in inconsistent colors.

NOTE: It's best that the printer used for your paintings is not used for text printing. Use a simple printer for text and save the more sophisticated inkjet for printing paintings.

Inkjet printers come in all sizes and the larger format printers can take up a great deal of floor space. It is better to start out with a smaller printer that can handle proofing and small final prints up to 13 x 19 inches (33 cm x 48.3 cm) and then decide if the amount of printing you do justifies the investment of time, money, and space for a large-format printer. My printers of choice are Canon, and I can print paintings up to 24-inches wide using roll papers on my biggest model. I use smaller models to print the proofs, and only use the large-format printer when we are sure the painting is ready for a final print. If a large-format printer doesn't fit into your budget or home, remember that larger paintings can always be sent to a lab.

A variety of paper and canvas can be used for in-house printing, so be sure you purchase a printer that can handle these different substrates. Test many different papers and canvases to find the right combination for your own style.

Red River Paper has beautiful fine art paper that is expressly designed for printing in-house. Every box comes with instructions and settings for combinations of various printers and their paper. Try out their Artistic Inkjet papers by ordering a sample kit at www.redrivercatalog.com.

Labs

Sending your paintings to professional labs assures high-quality prints and saves time. Almost all major labs now allow digital files to be uploaded via the Internet, making the process quick and easy.

Before sending anything to a lab, I always print out my own 13 x 19-inch (33 cm x 48.3 cm) print and look at it closely in the sunlight for changes I want to make. (If your printer is smaller than this, it will still be fine for proofing before sending the file to the lab.) I use a marker to circle each problem area and to note what needs changing. As I sit at the computer making changes, I cross off each area on the test print to be sure I have fixed it. Save the new corrected painting before uploading it to a lab.

Here are a few good labs on the Internet:

MPIX is an online digital lab for both the professional and advanced amateur. They can print your paintings on paper or canvas, as a book, greeting cards, playing cards, or calendars. New products are always being added. Try printing your non-portrait paintings on their Kodak Endura Metallic paper for a new richness of tones and sparkle from the metallic paper. Visit their website at: www.mpix.com.

Other online labs that will print your work on canvas and a variety of other products or media include :

www.pixel2canvas.com
www.simplycanvas.com
www.canvasondemand.com

Printing your digital artwork is one of the most rewarding parts of the process. Seeing the transition from the computer screen to the page is always exciting. And if you think about the countless possibilities for your artwork, from home decorating, to gifts, to graphic design, and more, then printing your work becomes a fun and integral step in the process, and not just an afterthought.

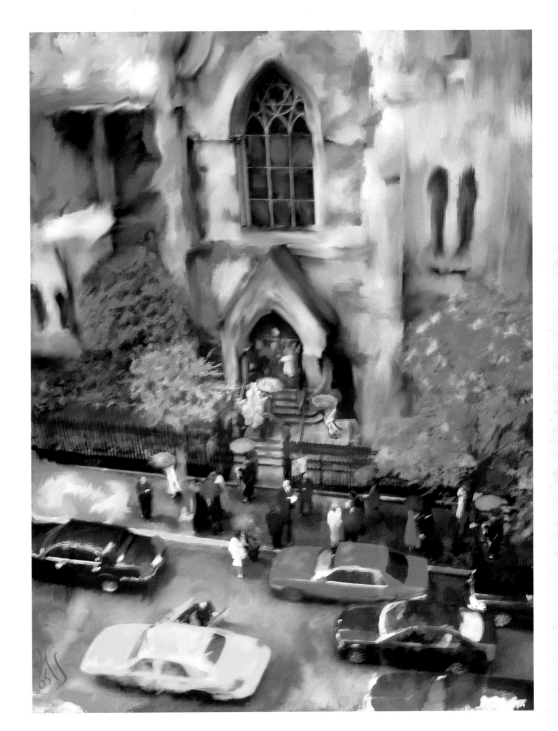

RESOURCES

Often there are discount codes for software and products available. To get the latest discount codes please check the website under "Resources" at
http://www.marilynsholin.com
While not everything in these resources was discussed in the book, they are all materials worth investigating and give a good overview into what is available for digital art projects.

SOFTWARE
Corel Painter X
www.corel.com

Nik Color Efex 3
Nik Viveza
Nik Sharpener Pro 2.0
www.niksoftware.com

Alien Skin Snap Art
Alien Skin Exposure 2
www.alienskin.com

Art Studio Pro Classico
Art Studio Pro Volume 1
Art Studio Pro Volume 2
www.twistingpixels.com

Virtual Painter 5
www.virtualpainter5.com

Lucis Art Pro
www.lucisart.com

PEN TABLETS AND DISPLAYS
Wacom
www.wacom.com

FINE ART PAPER and Printing Supplies
Red River Paper
www.redrivercatalog.com
Premier Fine Art Media
www.premierart.info
Hahnemuehle Fine Art Paper
www.hahnemuehle.com

Ink, Paper And Supplies
www.atlex.com

PROFESSIONAL PRINTING LABS
These labs will print on canvas, watercolor paper, photo paper, gift items, greeting cards, business cards, and metallic paper. Explore the labs for their products to fit your needs. Each lab has an extensive line of products for your paintings.

www.mpix.com
www.millerslab.com
(request info for the fine art printing)
www.pixel2canvas.com
www.simplycanvas.com
www.canvasondemand.com

A simple GOOGLE internet search for "labs that print on canvas" will find more labs online and one near you.

ALBUMS
Print Albums on the Internet
www.blurb.com
www.lulu.com
www.asukabook.com

Send Paintings to be Bound into Albums
www.pictobooks.com
www.tornpaper.net/
www.caprialbum.com/

GIFT ITEMS
Glass Tiles and Boxes
www.changeyourart.com
MISC. Shirts, mugs, bags, stamps and more
www.zazzle.com

FASHION HANDBAGS
www.bagsbybabycakes.com
www.snaptotes.com
www.bagettes.com

EMBELLISHING SUPPLIES
www.goldenpaints.com

PICTURE FRAMES
www.excelpictureframes.com

WEB DESIGN
www.studiochris.us

EDUCATION
www.marilynsholin.com
www.marilynsholinfineart.com/workshops
www.digitalpaintingforum.com
www.flicker.com/groups/digitalphotopainting/
www.digitalartacademy.com
www.lvsonline.com
www.painterfactory.com
www.paintermagazine.co.uk
www.paintercreativity.com
www. hannahseyesphotography.com
www.martinanddoreen.co.uk
www.pendarvis-studios.com
www.janesdigitalart.com
www.helenyancy.com
www.digitaltechnologycentre.com

"Marilyn Sholin Digital Painting Palette"
Step by step palette that automates painting like "Marilyn"
www.ronnichols.com/products/products.php

Free downloads of brushes and more tutorials:
www.digitalpaintingshop.com

Free Download of the original images for the tutorials:
www.marilynsholin.com

The Art of Digital Photo Painting: Using Popular Software to Create Masterpieces

Index

Afterword

The End is the Beginning

As with painting, it's hard to know when to stop writing. At this point the book may be finished, but your art will continue. And digital art may just be the beginning; there are many other options for working on the original image after printing, but sadly, we are out of words and pages to discuss embellishing. Take heart— there is more information on this subject on my website and in the Resources section of this book, where you will find other topics that may never have been covered in these pages. This is my way of forcing you to explore more options after turning over the last page.

Your journey is just now beginning. My apologies to you because now you will never be happy with just a "photo" from your vacation or a "picture" of your relatives! You will always want more— to paint and print and then paint some more. Every time you take your kids to the zoo it will be a day to turn into paintings. Simple photos of objects around your house and pictures of food at family dinners will become a series of still life paintings. The family antique car will be a painting instead of a pain in your pocketbook.

You are very welcome for all of these new visions of paintings. Now you can "see" more of what I see in the world when I look around. I predict that digital painting will be your new passion and you will want to continue taking that passion to new heights.